John Ahearn
Siah Armajani
Michael Asher
John Baldessari
Larry Bell
Lynda Benglis
Dara Birnbaum
Mel Bochner
Richard Bosman
Joan Brown
Scott Burton
Peter Dean
Rafael Ferrer
Jack Goldstein
Dan Graham
Jenny Holzer
Bryan Hunt
John Knight
Barbara Kruger
Sherrie Levine
Sol LeWitt
Robert Mangold
Robert Moskowitz ·
Elizabeth Murray
Bruce Nauman
Katherine Porter
Stephen Prina
Martin Puryear
Martha Rosler
Susan Rothenberg
David Salle
Julian Schnabel
Joel Shapiro
James Turrell
Richard Tuttle
Christopher Williams
Ray Yoshida

74th American Exhibition

The
Art Institute
of Chicago

June 12–August 1, 1982

Designed by John Greiner Associates, Chicago
Typeset by MobiGraphics, Inc., Chicago
Printed by Congress Printing Company, Chicago

Photo credits:
No. 1: Eric Pollitzer, N.Y.C.; Nos. 3, 26: Anne
Rorimer, Chicago; Page 15: Jon Abbott, N.Y.C.;
Nos. 6, 42: Geoffrey Clements, N.Y.C.; Nos. 10,
22, 41, 53: Alan Zindman, N.Y.C.; Nos. 17, 52:
Roy M. Elkind, N.Y.C.; No. 36: postcard of Franz
Marc, *The Large Blue Horses*, 1911, oil on canvas,
Walker Art Center, Minneapolis, gift of T.B.
Walker Foundation; No. 38: J. Ferrari, N.Y.C.,
for John Weber Gallery, N.Y.C.; No. 44: Glenn
Steigleman Inc., N.Y.C.; No. 58: eeva-inkeri,
N.Y.C.; No. 59: Warren Silverman, N.Y.C.;
Page 46: Thomas Cugini, Zurich; No. 62: William
H. Bengtson, Chicago.

Preface and Acknowledgments

With the advent of the 74th American Exhibition it becomes again our responsibility to state the purpose of this occasion, which occurs for the 74th consecutive time within 94 years of the museum's history. Originally an annual event, the present biennial rhythm copes more realistically with the proliferation of accessible art. The goal of the exhibition remains the presentation of significant trends in painting, sculpture, and related media today. This concept is based on the idea that individual selections have been executed as recently as possible, or within the two-to-three-year period between the present and preceding exhibitions. The number of works representing each artist varies: a painter of small format may show several pieces, while another artist might be presented through a single statement. This year, for the first time, the exhibition takes place simultaneously in two different areas of the museum: the Morton Wing and the A. Montgomery Ward Gallery. Although these are not contiguous, the enlarged space permits more exhibitors, greater breadth of work by each artist, and freer juxtapositions that we hope will enhance the viewer's understanding of current activity in American art.

From its inception, the American Exhibition has featured a Jury of Awards. Selected by the Art Institute, the jury is composed of three qualified figures in the art world who may range from artist to pundit. This year the jury's members are Benjamin Buchloh, Visiting Professor, California Institute of the Arts, and Editor, the Press of the Nova Scotia College of Art and Design; Richard Koshalek, Deputy Director, Los Angeles Museum of Contemporary Art; and Brenda Richardson, Curator of Painting and Sculpture, the Baltimore Museum of Art. This jury grants the considerable award monies made available to the exhibition through donations over the years (we have long abandoned the original, and now archaic, system of graded prizes in favor of equal awards). The jury can also assign purchase prize awards to be consummated at the discretion of the museum, and in this way the American Exhibition has long been a valuable source for vital additions to the permanent contemporary collections of the Art Institute. This year we are fortunate to receive out of the exhibition *Rayna* by James Turrell. This is the gift of the Society for Contemporary Art, the generous and effective support group of the 20th-Century Department, among others in the museum, which has made possible the acquisition of many major works of art for our collection. The Society's purchase of the work in advance of the exhibition enabled us to implement the piece in situ, as well as to reinstall it eventually in the permanent galleries.

As the organizing curator of the American Exhibitions for many years, I visualize them in sequence, over limited time spans. While this exercise of memory perhaps is more applicable to the curator than to the public, since it inevitably contributes to planning, we hope it might be relevant for the museum visitor. For example, the 72nd exhibition occurred in 1976, coinciding with the nation's bicentennial anniversary. It seemed fitting that the exhibition contribute to the national event by emphasizing the breadth and quality of contemporary American art. Thirty-eight participants, including leading masters over three generations, beginning with Willem de Kooning, were invited to show their best, most current work. The exhibition was a celebration of achievement. On the other hand, the 73rd exhibition was small, tightly trimmed to show only 16 artists with predominantly purist, minimalist, and conceptual approaches. That exhibition reflected consistency, concentration, and clarity, in contrast to the panoramic elaborations of the preceding show. The installations were predominantly white, pitted against the exotic explosion of color and form in one three-dimensional painting by Frank Stella which offered the presage of a future that has become manifest in the interim. Now, in 1982, the exhibition assumes another character altogether. With 37 artists included, it is almost the size of the 72nd exhibition six years ago. Yet, the 74th exhibition is not intended to offer any summation or significant pause. Rather, we wish to suggest the cross currents operating in American art today, in order to convey a modicum of the excitement, volubility, and energetic multiplicity of the moment.

Even though this is a large exhibition for the Art Institute of Chicago, it is not easy to suggest the complex situation in contemporary American art by means of the work of only 37 artists. Our selection is therefore quite stringently limited in regard to artists who have had repeated exposure here before; such individuals have been included only when their present work constitutes a new departure for them or provides a particular liaison with other works in the show. Also included is a group of established artists who have been working within their present idiom for a number of years, whose vision seems in particular focus now, and who have not exhibited here before. Finally, a considerable portion of the exhibition is devoted to younger artists who have received widely varying degrees of public attention but who are exhibiting here for the first time. Their work offers exhilarating insights into the contemporary scene across the many facets of media, principles, and styles. While we are reluctant to categorize the work in this exhibition, we do see in it four major directions. First, there is a deep interest in working with space, light, and construction. Second, there is intense exploration of paint—its textures, colors, and expressive potentials, whether one's concerns are figurative or abstract. Third, we find a definite strand of lyricism, with artists inspired by natural or vernacular sources or by more purely aesthetic considerations. We

also present a provocative group of conceptual works—rational, intellectual, and in contradistinction to traditional means and ends.

The exhibition was organized by myself and by Anne Rorimer, Associate Curator, Department of 20th-Century Painting and Sculpture. I am particularly indebted to her for her counsel and for her thought-provoking essay. We were aided immensely by other members of the 20th-Century Department: Courtney Donnell, Research Assistant; Susan Friel, Departmental Secretary; Kathy Cottong, Special Assistant for Administration; Judith Cizek, NEA Intern who compiled the catalogue's biographical and bibliographical documentation; Andy Leo, Installation Assistant; Rufus Zogbaum, Preparator. We gratefully acknowledge, too, the assistance of many other departments of the Art Institute. While we cannot thank everyone here by name, we would like to mention in particular Reynold Bailey of the Art Installation Department and his remarkable staff; Wallace Bradway and Mary Solt in the Registrar's Office; Ann Dole, Director of Placement, Career Planning and Cooperative Education, School of the Art Institute; and Susan F. Rossen, Editor and Coordinator of Publications, whose patient guidance and insightful editorial contributions to the introduction made possible this catalogue. We are also grateful to John Greiner for his considered catalogue design. We are deeply beholden to the many private galleries as well as the individual lenders to the exhibition for their generosity and cooperation. Finally, and above all, we wish to express our special thanks to all participating artists.

A. James Speyer, *Curator*
Department of 20th-Century Painting and Sculpture

Introduction

The 74th American Exhibition, with no claim to all-inclusiveness, presents a cross-section of work conveying a wide spectrum of current activity in American art. The exhibition features works done in the 1980s by 37 artists at different points in their careers. These artists have exhibited over differing periods of time—some since the early or mid-1960s, many since the late 1970s, and others only very recently. Thus, several of the participating artists have taken part in the formation of the existing historical framework by having questioned established practices passed on to them by history, while others are in the process of opening new avenues of thought. At a time of heightened critical controversy about the direction of artistic thinking, when the idea of a continuing notion of Modernism is being questioned and the term Postmodernism remains an imprecisely defined substitute,[1] a contemporary exhibition in a museum context can function as an open forum for the consideration of some aspects of the present situation, allowing as it does for the direct visual confrontation of a range of specific works. This exhibition seeks to demonstrate the current state of artistic affairs by acknowledging a complex network of coexisting issues. Within this nexus of ideas a number of areas of concern may be determined, including a revival of traditional painting, a continuing involvement with concrete three-dimensional form, and an exploration of art in relation to the surrounding environment—physically or socially defined.

Over the last two decades, when a number of artists chose to abandon traditional media and formats to seek new modes of expression, painting seemed threatened with obsolescence. However, in the early 1980s, the discipline seems to have been revived, with artists, critics, dealers, and museums all exhibiting renewed interest in it.[2] The broad issues being dealt with in painting today include the numerous combinations and relationships between abstraction and figuration, the inside of the canvas field and its edge, geometrical and expressionistic treatment of forms, the visible handling of paint or intentional absence of the hand, the use of pre-existing as opposed to original imagery, and the expression of personal or subjective meaning rather than of social consciousness. Other related or opposing aspects exist, of course, but the above suggest some of the parallels that can be drawn and juxtapositions that can be made.

Robert Mangold and Robert Moskowitz belong to a generation of artists that has been engaged actively in painting for nearly two decades. A comparison of the work included in the exhibition reveals their contrasting approaches to the canvas field and serves to articulate certain essential questions underlying painting at this juncture in time. In his *Painting for Three Walls* Mangold has divided the surface by linear elements that outline and/or dissect the canvas area in respect to its spatial confines. Slight deviations from a strict rectilinearity are a further reminder of the canvas's existence as an object in its own right rather than as a surface for representation or expression. The three canvases of his triptych surround the viewer as demarcated fields of high-keyed, matte, processed color. Together, they create a harmonious unity between separate, flat picture planes which have been aligned with each other in a three-dimensional, spatial relationship. Moskowitz, on the other hand, deliberately effects the reverse. Rather than treating the painted canvas in a totally self-referential manner, he confirms the fictional nature of the picture plane in order, paradoxically, to substantiate painted reality. He establishes that figuration is a fiction by asking the viewer to consider how a painted image is defined when lodged within and upon a painted ground. Dealing with essential questions of painterly rendition, Moskowitz points out that a painted image is both figurative and abstract, fixed within the fictional context of the painting's specified boundaries. Abstract form and concrete image merge in *Black Mill*. The shape of a windmill, generally an imposing feature in a landscape, here dominates the picture plane as an inseparable element of the painted ground. Such a painting fulfills Moskowitz's intention "to paint with such intensity that the work becomes believable."[3]

In the mid-1960s Mel Bochner chose to abandon painting on canvas to become involved with "artificial mental systems" based on geometric and numerical relationships.[4] In a significant body of work that moves between drawing, painting, and sculpture without regard for any of these boundaries, he explored processes of thought and perception, the connections between visual and verbal language. Recently, he shifted to painting on canvas, transferring and adjusting his formal investigations to considerations prompted by the canvas surface. The linear elements of *Thickness of Time*, structured as they are in relationship to the canvas edge, construct a sequence of shapes, at once enclosed and open, which connect multiple, internally spaced points. The painting, with its layered network of lines of varying density and color, reveals Bochner's continuing quest for the perception of geometric shape, seeing, as he does, in terms of "point, line, edge, enclosure, numbers of sides, angles of orientation, counting…"[5] Building his "painted" construct up from the canvas surface, Bochner offers a complex skeleton which moves through various alternatives toward resolution.

Both Rafael Ferrer and Elizabeth Murray bring to their highly individualized art a renewed emphasis on instinct, bold formats, great freedom of form, and theatricality. In her recent paintings Murray has dispensed with conventional rectilinearity and homogeneity. Colorfully painted,

large biomorphic shapes, as if cut loose from the confines of the canvas, burst forth across equally eccentric shaped canvas parts, disregarding open spaces. Before *Back on Earth* one is confronted with an intense drama that seems to be occurring on the wall between painted and canvas shapes. A concentration of intertwined forms evoking natural and anthropomorphic references imbues the painting with such a sense of life that it takes on rich connotations of human experience and feeling. Ferrer's recent paintings possess the lush paint surfaces and color, audacious form, and sardonic spirit that have characterized his work in a variety of media over many years. While his *Junio (Triptych)* owes something to Matisse, its conscious primitivizing, frank sensuosity, and impudent humor are all very central to Ferrer's own unorthodox vision.

The paintings of Susan Rothenberg and Katherine Porter signify a return on the part of younger artists to an exploration of the emotional implications of thickly painted surfaces and abstracted images. Rothenberg's approach weds the sophisticated with the instinctive. Her figurations (whether of horses or, more recently, of humans)—heavily painted, sparely colored, highly concentrated with their emphasis on edge—emit a haunting, visceral power. In *San Salvador* Porter seems to combine the dynamic visions of the Synchronists with the impasto and gestural paint application of the German Expressionists. The result is a volatile surface that seems to shatter into violent explosions of conflicting (but essentially similar) forces, as the artist comments on a profoundly disturbing political situation.

While these artists search in their work for emotional immediacy or relevance, Ray Yoshida maintains a conscious aloofness by portraying figures in isolated worlds of painterly pattern. Reference to the exotic art forms of other cultures such as the ancient Mayan civilization reinforces his evocation of timelessness and remoteness. Like Yoshida, Joan Brown has pursued a very individual figurative style for many years. However, in her work she clearly acknowledges links with her life. *The Long Journey* is a recent addition to Brown's *Journey* series, metaphors for her personal quests and evolution. A potted plant and a veiled woman riding a tiger are set against a solid, dark background. The insistent simplicity of the forms and patterns underline the emblematic character of the images. Traveling silently in her highly patterned costume atop a powerful, striding animal, the woman becomes an immutably strong image, seeking her future with determination and a sense of destiny.

Much current painting, whether figurative or abstract, looks back to earlier 20th-century styles, to German Expressionism, in particular, suggesting, perhaps, certain artistic and social parallels between our present situation and that of Germany before World War II. The works of Peter Dean and Richard Bosman testify to the thin line that exists in our society between fantasy and violence. In Dean's *Don't Touch Me I'm Crazy Horse* bayonets attack a frenzied figure in Indian headdress, and in Bosman's *Adversaries* a bear-like creature with long claws wrestles with a human figure brandishing a knife. The imagery of both paintings would seem to derive from youthful, boyish fantasies. Bosman acknowledges inspiration from Chinese comic books, 1940s mysteries, and television; and Dean has stated, "I am involved with both fantasy and reality of my life and times..."[6]

Jack Goldstein is also concerned with violent imagery, but in his elegantly airbrushed canvases of nocturnal air battles the violence appears apocalyptic and visionary. Beams of air-raid light in *Untitled (MP #50)* become aestheticized and anesthetized as they crisscross the canvas sky; one is confronted with a beautification of war. Goldstein appropriates his imagery directly from World War II news reportage photographs, which he projects on canvas for assistants to airbrush in black and white. Personal absence marks his paintings as it did his earlier performances. Not only do assistants perform the task of painting, but the subject itself has been several times removed from its actual war-time source, which contributes further to the mythification process.

Whereas Goldstein's images are clearly identifiable, those of Julian Schnabel and David Salle are intentionally subjective. The canvas for these artists provides an hermetic world in which external reality is diffused upon the surface. In a recent lecture Schnabel maintained, on the one hand, that his "paintings tell you what life is about now," while, on the other, he stated that "art is incongruous with life."[7] Schnabel's paintings, as distinct from Goldstein's, manifest a material physicality. Following in the tradition of Robert Rauschenberg's combines, Schnabel encrusts his painted surfaces with non-art materials, construing forms in *Voltaire* with China plate fragments and other natural and manmade objects. Fragmented, abstract, or evocative shapes, as well as remnants of mundane life embedded in the paint, physically root his works in the world, while their ultimate meaning remains elusive.

David Salle's involvement with the easel painting is connected to his desire to re-invest images found in the public domain with private significance. He has discussed an image as "a thing emptied of meaning...[having] a peculiar character of seeming to signify something but actually refraining from doing so."[8] *The Old, the New, and the Different* defies precise interpretation. Salle has divided the painting into two unequal sections. In the larger, left-hand area brightly colored brushstrokes and flecks on a dark background, recalling Abstract Expressionism, indicate figuration. The right-hand section depicts a scene taken from a photograph of a girl and boy tied to a tree-trunk. Such juxtapositions of relatively abstract passages with unexplained narratives demand that the viewer surmise or supply the missing links and question the meaning of the relationships.

The recent revival of painting and the concurrent phenomenon of painters turning inward to subjective vision have engendered conflicting critical responses. Some writers have greeted this development with obvious relief; others interpret it in terms of new-found faith;[9] while still others see in it a nostalgia indicative of regression and cultural oppression.[10] Barbara Rose has written enthusiastically, "Last year, I began to see a lot of painters.... Dozens of artists had begun simultaneously to 'break through'—not to some radical technique or bizarre material—but to their own personal images,"[11] while Craig Owens, commenting critically on the growing phenomena of painters turning inward to subjective vision, has remarked, "Individual artists' retreats from politics and into the psyche are only symptoms of a much more extensive cultural shift, which must be analyzed in detail."[12]

The issues around the three-dimensional work in this exhibition necessarily differ from those faced in the paintings, although they are related. The work on view in the exhibition illustrates differing aspects of recent sculptural intent, whether of a strictly formal, material nature or imbued with social content. In the 1960s, traditional approaches to sculpture were initially redefined by such artists as Donald Judd, Carl Andre, and Dan Flavin, permitting new options for the formal and material nature of sculpture to emerge. One of the significant participants in the "reform" of sculptural ideas was Bruce Nauman, who used "non-sculptural" materials like fiberglass and developed works that questioned existing sculptural concepts. The piece by Nauman shown here is part of a recent series entitled "Silence. Violence. Violins." In this series Nauman elaborates upon his long involvement with language, space, and form, attempting to push these concerns to the edge of social commentary. Complex levels of formal, physical, and iconographic exploration are at work in this monumental piece. A large, trapezoidal structure, made up of heavy steel beams suspended from the ceiling, protrudes menacingly into the gallery space. A chair hangs at its center upside down and, when struck in different places, sounds the musical notes D, E, A, D; the words "Diamond Africa" have been written inside the steel structure. Punctuating the silence, the reverberating tones reinforce the intrusive quality of the piece's material form. Its threatening character is further underlined by associations of the steel chair with interrogation and persecution.

Joel Shapiro's investigations over more than a decade have centered on an analysis of the tradition of sculpture itself. Through the deliberate apposition within a single work of mass and space, abstraction and figuration, interior and exterior shape, Shapiro explicates the various components of sculptural form. Each specific sculpture becomes a generalization of sculpture, defined as a material object occupying space in either a representational or abstract way. Richly invested with traditions and associations, the sculpture illustrated on page 44 evolves out of the more recent minimalist aesthetic, yet recalls, as well, the simplified, geometric figures of Constantin Brancusi. By telescoping contemporary and early 20th-century styles into one piece and employing traditional materials such as wood and bronze, Shapiro distills the principles and traditions of modern sculpture and succeeds in expanding its definition.

Whereas the sculpture of Shapiro concentrates on formal issues, that of Lynda Benglis emphasizes materiality and, at the same time, frees material properties from standard expectations. The industrial quality of the materials comprising her "knot" sculptures contrasts with their underlying organic form, which appears simultaneously to flow and be frozen in place. Speaking of her intentions, Benglis has stated that she "wanted to make something very tactile, something that related to the body in some way..."[13] The new pieces, in silver or gold, attain a Rococo elegance and élan. Bryan Hunt also explores the behavior of materials. In a shift similar to that reflected in the renewed interest in the four-sided oil on canvas, Hunt recently has taken up bronze casting, making pieces in which he focuses on such traditional concerns as weight and gravity, the artist's interaction with materials, the interrelationship between sculpture and base, and heroic figural depiction. The thin legs and back of Lafayette Chair support a thick, amorphous mass that,

in an earlier stage of the work (see page 28), was molded in plaster and scraped by hand. This material "body" of bronze is draped over the chair like a cloth or relaxed figure. Placed on a stone base, the work brings to mind a long history of celebratory monuments that one encounters in parks and squares everywhere—bronze sculptures of heroically draped, notable figures seated in grand chairs which, in turn, are elevated on pedestals.

Scott Burton injects a further dimension into the definition of sculpture by purposefully merging form with function, "high" art with industrial or decorative art, the art object with the real object. Since 1976 Burton has made sculpture in the form of furniture, inspired by the evocative shapes and anthropomorphic "character" of actual tables and chairs. His unique reproductions of mass-produced contemporary furniture at once extend and complicate the idea that an artist's selection of an object removes it from life and makes it art, since Burton intends his furniture pieces to function in both worlds. More recently, he has been increasingly involved in producing furniture, such as Aluminum Chair, which he designs himself. Yet, despite the utilitarian nature of such pieces, their form, surface, and detail are so self-consciously exaggerated and manipulated that they "become mannered and strange—objects meant to be contemplated at an aesthetic distance."[14]

Another artist whose work exists provocatively on the edge between life and art is John Ahearn. The most specifically figurative sculptor in this exhibition, Ahearn has been creating a group of portrait busts depicting inhabitants of the South Bronx in New York City, where he lives. After making casts (either in plaster or fiberglass), he then paints them with high-keyed colors that heighten the exact replication of the physical features and peculiarities of the subjects. Evolving out of an ancient tradition of realistic wax portraiture, Ahearn's busts possess a particularly vivid, often eerie presence, the result, perhaps, of their obsessive realism and the direct and clear way in which they convey a range of emotions—pride, joy, energy, potential violence, etc. Ahearn presents each of his models with one of the casts he makes of them; so, too, the monumental frieze Homage to the People of the Bronx, depicting neighborhood children at play, which is being shown for the first time, is intended by Ahearn for an outdoor setting in the South Bronx.

Martin Puryear's work integrates the organic with the structural, the natural with the man-made. In Sanctuary two parallel trunks of saplings, intertwined with each other at their roots, connect to a wheel below and to a platform and vaulted roof structure above. The sculpture is attached to the wall at the top, permitting the wheel to barely touch the ground. As the title suggests, the piece carries associations beyond the purely formal and material. The wheel, implying movement and impermanent location, is tenuously connected with the earth, while the inaccessible platformed structure above offers stability and permanence. Evolving from the artist's sensitivity to the instability of contemporary life, Sanctuary offers the viewer a metaphor for the search for refuge and peace, physical and spiritual gifts that both art and nature can provide.

Siah Armajani challenges traditional assumptions about sculpture by defining it in relationship to architecture. Dictionary for Building: Fireplace Mantel evolves from his

systematic study of essential common architectural units, such as doors and windows, found in vernacular American buildings. This work is not a single, literal fireplace mantel but rather a composite of elements—such as the simplified wooden components attached to the wall and the traditional mirror—brought together and restructured in order to render the notion of a mantel. By splaying the construction out into its various parts, Armajani suggests not only its structural vocabulary but also the essence of the mantled fireplace, which constitutes the core of a house or a room. The mirror permits the viewer to visually penetrate the interior of the complex structure. The inclusion of an inscription, from a poem by Robert Frost, ''They had learned to leave the door wide open until the fire was lit,'' underlines the symbolic level of a piece that because of its sculptural definition transcends literal interpretation.

While the architectural concerns of Armajani's piece relate it in certain ways to Dan Graham's *Pavilion/Sculpture for Argonne,* the material properties of Graham's sculpture must be seen in relation to its social environment. *Pavilion/Sculpture for Argonne* is activated by visitors who, entering it, become part of the work by observing themselves and those observing them. The work for which the piece in the exhibition is a model is intended for outdoor display, which would involve the sculpture in a further dimension, that of changing light and atmospheric conditions. Significantly, in Graham's work the traditional separation between viewer, work, and environment has been virtually eliminated in a radical redefinition of sculpture.

In the 1960s a number of artists residing in Southern California began working with materials that filter or reflect light. Among them, Larry Bell and James Turrell have continued to explore these concerns. For Bell light is a demonstrably physical material, as palpable and impalpable as the transparent materials and space it passes through and defines in his work. The piece on view in the exhibition evolves from an installation Bell did in 1970, in which he mounted a series of coated glass shelves that transmitted and reflected color from the interior light of a gallery space.[15] In *The Corner Lamp SB-6* a single light shines from above onto a semi-circular, bevelled glass shelf which has been chemically treated so as to cast elliptical reflections from the top corner of the room to the bottom, both above and below the shelf, which itself appears to dissolve as it filters light and radiates pure color. Bell conceives of this piece as both functional and aesthetic and, in other situations, has incorporated furniture he has designed into the multi-colored space *The Corner Lamp* creates. Such a piece as *The Corner Lamp SB-6* demonstrates the artist's continuing absorption with sensuous and translucent surfaces.

On the other hand, for Turrell, the ''play of light'' becomes a more cerebral game of perception and deception. In earlier work Turrell projected onto walls apparitions of solid, cubic forms of light which looked as if they were hanging in space. More recently, he has created illuminated chambers in order to produce illusionistic light effects. *Rayna* belongs to Turrell's ''Space Division Constructions'' series, first developed in 1976. An enclosed room with a door at one end has been divided into two sections. One is that of the viewer, the ''sensing space,'' as Turrell terms it; the other is ''looked out onto'' through a large, rectangular aperture cut into the

dividing wall. The rectangular opening can be perceived by the viewer in two ways: as a wafer-thin plane of light suspended in space and as infinite space. Both perceptual phenomena are based on the reception of light on the retina, to which Turrell attaches a mystical or, at least, otherworldly interpretation. As he has written, ''The power of the physical presence and tangibility of the light-filled space and its changing sense of existence tend to make it feel like the dream that coexists with the awake state.''[16]

The artistic innovations witnessed over the last two decades go hand in hand with works that have extended the definition of painting and sculpture beyond the singular presence of the contained, circumscribed object. In this regard Sol LeWitt has been deeply influential. In sculpture, painting, and drawing he has sought to integrate the art object with the surrounding space. By drawing directly on the wall (which he first did in 1968), LeWitt ''draws'' the given surface area or room into the visual fabric of the work. Until recently he followed a predetermined plan for a series of lines that could be applied to different spatial circumstances and, in so doing, achieved complete fusion of form and space. In the piece exhibited here large, consolidated isometric shapes carry on an ambiguous relationship with the walls. The commanding forms seem to be totally encompassed by the supporting wall, and appear as well to actually hold them up. The wall, like the shape drawn on it, becomes a solid, physical participant in the interaction between form and environment.

Around the same time that LeWitt began to formulate his ideas, other artists were becoming involved as well in articulating the implications of the background wall. First exhibited in 1965, Richard Tuttle's early painted plywood forms, because of their irregular shapes and direct contact with the wall, alluded to the interrelation of the spatial support and the elements imposed upon it. The spatial interstices between Tuttle's forms have always carried the same weight as the forms themselves. His recent, delicate gouaches must be viewed as two-dimensional totalities containing those components that have concerned him previously—form, scale, framing, and placement.

Much greater attention has been paid by artists in our media-oriented society to the presentation of *representation.* Firsthand/secondhand experience—provided by the omnipresent systems of representation—suggests multiple aspects of reality. As Douglas Crimp articulated some years ago, ''To an ever greater extent, our experience is governed by pictures, pictures in newspapers and magazines, on television and in the cinema. Next to these pictures, firsthand experience begins to retreat, to seem more and more trivial. While it once seemed that pictures had the function of interpreting reality, it now seems that they have usurped it. It therefore becomes imperative to understand the picture itself, not in order to uncover a lost reality, but to determine how a picture becomes a signifying structure of its own accord.''[17]

Since 1965, when he ''became weary of doing relational painting and began wondering if straight information would do,''[18] John Baldessari has proceeded to analyze connections between image and text, form and content, art and art history. *Fugitive Essay,* a photographic work in three sections, is a storyless narrative about the decision-making process that determines what can be communi-

cated within a given set of conditions. In this piece he has explored relationships between placement, image, and shape. One image, seen at eye-level, is straight-forward and academic; in the second, placed near and parallel to the floor, subject matter has been tailored to the photograph's shape; and, in the third, installed near the ceiling, the subject has determined the image's shape. The photographs themselves release no specific message. A roll of towels, a landscape with rolling ball, and a zebra are all evocative in juxtaposition, but, as images, they must be taken for what they are. Form and format vie for precedence, and information relies on the means of delivery, here deliberately divulged. Baldessari's long-term commitment to photographic imagery as a means of restructuring pictorial convention has provoked as well a questioning of the nature of photography.

Source, The Photographic Archive, John F. Kennedy Library by Christopher Williams raises vital questions concerning presentation and representation. Four tradi-tionally matted photographs hang in the exhibition. The accompanying label text has been separated from the images and is found, instead, on page 64. (Williams decided not to place it within the design format of the checklist which follows.) The physical disconnection of the two normally allied modes of representation, text and image, serves to heighten awareness of the viewing process. Within the context of an art exhibition, the work isolates material drawn from the public domain so that it might be read in a form other than the one for which it was intended. While the images of the late John F. Kennedy do not depict an historically memorable moment, perception of the work is contingent upon all prior knowledge of the images of Kennedy which here are brought to mind. Significantly, the text does not explain the images nor the reasons for their selection. Rather, it relates the necessary facts connected with procuring the photographs from the Kennedy Archive and with preparing them as if for publication, by following standard procedures for rephotographing, enlarging, and cropping. As one observer of this piece has pointed out, "The work...attempts to force the cultural image into a position where the machinations at work in the production of its meaning may be exposed."[19] The work's meaning incorporates the entire system that governs the dispensation and manipulation of photographic information.

Historian Alan Trachtenberg has observed, "Within the structure of culture whereby a photograph represents an instant, unmodified and unmediated, re-play of lived experience, the photographic image seems to enjoy an unchallenged claim to 'truth,' to a privileged access to 'reality.' With their mythic authority as tokens of reality, images tyrannize over subjects; they ready people for exploitation and manipulation."[20] Barbara Kruger's recent pieces, resembling photomontage, confront the "reali-ties" of contemporary culture through reference to its own tactics. The works include statements composed by the artist, which "speak" in the second person to the viewer with the definitiveness of magazine advertising, which they graphically resemble. The single, enlarged photographic images, drawn from the pre-World War II era, with which the statements are coupled connect with what is being said on both literal and elusive levels. Yet, the emphatically black and white text and image fall into grey areas of interpretation when a viewer, conditioned to receiving authoritative, personalized messages,

demands a "correct reading." The seeming objectivity of communication graphics has been turned inside out as the artist explores the subversion of traditional forms into manipulative informational systems.

Imperative and descriptive statements pertaining to any number of subjects, situations, or belief systems form the basis of Jenny Holzer's work. Texts, repeated on squares of uniformly sized but differently colored paper glued to the wall, display an array of contradictory affirmations. The writings synthesize, paraphrase, mimic, or inter-weave a wide range of idiomatic truisms, opinions, or bodies of information. The colors of the sheets have nothing to do with the message they carry nor with any decorative intent. Rather, the colors are intended to attract attention to the sheets, which the artist originally and anonymously placed in public areas alongside other signage and graffiti. In an exhibition context, the wall, covered from floor to ceiling with statements, "supports" all manner of viewpoints. As a whole, the work demands that one "see through" it upon grasping its many-sided nature. Riddled with contradictions, it becomes in a sense transparent. As one viewer of Holzer's work has observed, "All of [her] statements are made to appear banal (not mystifying) and unsubstantiated. Unlike most 'political' art, which *a priori* begins with a worked-out belief and then employs a methodology to prove it, Holzer's statements deconstruct *all* ideological (political) assumptions."[21]

Myths and ideologies propagated by the media play a part in constructing, promoting, and enforcing images of reality. In her video work Dara Birnbaum confronts cer-tain kinds of imagery on their own terms, exhibiting their alluring and powerful artificiality by allowing them to speak for themselves. In Birnbaum's video/sound installa-tion *PM Magazine* an enlarged photographic video still, its mechanically reproduced look softened by markings, surrounds a television monitor screen. The still and monitor, in turn, are supported upon a wall painted in a vibrant "video-blue" that corresponds to a blue matte effect in the video picture. The piece cantilevers into the exhibition space like a flat, floating, and disconnected billboard. The large photographic still, taken from a word processor advertisement, depicts a woman sitting at a computer terminal with her hand raised, about to make a decision. The video monitor, countersunk within the photographic still, displays in a three-minute loop scenes from contemporary American culture which the artist has appropriated and edited from the ad and from the tele-vision program "PM Magazine." Nancy Hoyt described a related work by Birnbaum as "a set [of] the world we are coming to know....[Birnbaum] captures and plays with a microsecond of time and therefore reveals for the viewer the electronic processes that can feed us information so instantaneously that they often mask the essential ques-tions of our times. Where are we headed in this elec-tronic age? What visions, real and illusory, will this new era bring? Or, perhaps, do we continue to consume the same message just delivered in new ways?"[22]

Also by means of video, but with a decidedly different approach from that of Birnbaum, Martha Rosler, as she herself has stated, "challenges the mythical explanations of everyday activities, explanations that serve as ideo-logical justifications for them."[23] The video medium allows Rosler to take advantage of the way in which material is presented on television and at the same time

permits her to adopt a critical point of view with regard to social value systems ingrained by the mass media. Rosler's tapes "point to situations in which we can see the myths of ideology contradicted by our actual experience."[24] The three works shown in the exhibition present, respectively, an enacted scene of parents discussing the death of their anorexic daughter, a parody of a television commercial demonstrating Oriental cooking methods, and a view of the varied aspects of street life in San Francisco. Rosler's work is devoted to social realities as they exist both in the world at large and in daily life.

In his *Journals Series* John Knight succeeds in redefining traditional concepts of the art object through subscription, literally and figuratively, to the fiats of vernacular culture. Since 1978 he has sent over 50 subscriptions to various magazines to a variety of people he knows. The gathering of a number of these journals together for the purpose of museum exhibition brings the multiple implications of this piece full cycle. The work depends on the choice of recipient as much as it does on the choice of magazine, since the magazine's character is thrown into relief by the life-style of its particular recipient. Daniel Buren, for example, a French artist who travels worldwide for his art, received *Arizona Highways*. Artist and art historian Ian Wallace and architect Frank Gehry both got the high-gloss, fine arts periodical *Portfolio,* while *1001 Home Decorating Ideas* and *Apartment Life* were sent to persons living in small or unpretentious quarters. When viewed in the context of art—in the art institution or the home—the magazine subscriptions bring to the fore issues regarding cultural value systems. Within the museum context the journals become subject to standards of display and "aesthetic quality." Steeped in communications conventions, the *Journal Series* in a museum display paradoxically forces us to question our assumptions about the stock of rules we have for viewing art. Thus, the *Journals Series* uncovers modes of seeing in both the worlds of art and popular culture, asking us to consider how these may or may not be conjoined.

Stephen Prina's work *Aristotle-Plato-Socrates,* installed on three walls, suggests the complexity of visual perception pertaining to cognitive understanding. On the first wall one encounters the words of the three philosophers taken from a dictionary of quotations and shown in their actual page form. On the second wall are full-scale color reproductions of Rembrandt's *Aristotle Contemplating the Bust of Homer* and David's *Death of Socrates,* famous representations of the historical protagonists. The third wall utilizes an audio tape in two ways—presenting the quotations orally and using actual tape as a measuring device. By employing measurement and subsequently a mathematical comparison of the measurement, a denotative system of representation is introduced. The spectator stands at the center of the work to receive and absorb the various systems of information. He or she is in a position to distinguish and integrate the separate threads of discourse that make up the total piece. The selection of two paintings from different historical periods addresses the history of cultural reproduction with all of its attendant biases, models, and methods, while the replication of these masterworks focuses attention upon the essential character of reproduction as related to representation. The quotation from Aristotle in this work, "Plato is dear to me, but dearer still is truth," might serve as an epigram for contemporary work that desires to penetrate

highly evident yet intangible structures influencing our vision not only of reality but also of art.

The critical issues of art and photographic reproduction raised by Walter Benjamin in his famous essay of 1936, "The Work of Art in the Age of Mechanical Reproduction," underlie the work of Sherrie Levine. *After Franz Marc* comprises six four-color, poster-size reproductions found and framed by the artist. Benjamin articulated the fact that "Even the most perfect reproduction of a work of art is lacking in one element: its presence in time and space, its unique existence at the place where it happens to be."[25] In this work Levine has turned the problem of reproduction inside out, questioning the very concept of originality.

In contrast, Michael Asher has conceived a piece for the exhibition in relation to the Art Institute's permanent collection that restores the authenticity of the work of art that, as Benjamin pointed out, is jeopardized in our mechanical age. The work, discussed by Asher on page 14, consists of two groups of three viewers who stand in front of two separate works of art in the same gallery. One of these works has been reproduced often, the other much less. As Asher states, he has structured this work according to the premise of the specifically modern dilemma described by Benjamin when he wrote "...that which withers in the age of mechanical reproduction is the aura of the work of art."[26] The work by Asher revolves around the process of viewing as this occurs in a large, general museum and aims to dismantle the barriers of viewing which are caused by reproduction and reinforced under the auspices of the institution itself through its distribution of reproductions. The presence of viewers within the physical confines of the piece serves as a model for the museum visitors' own viewing, leading them to greater awareness of the two specified works of art while underlining their own responsibility in the critical act of viewing art. In a now well-known statement Marcel Duchamp stipulated that "the creative act is not performed by the artist alone."[27] Asher completes this creative act, which must be completed once again by the museum visitor looking at Asher's work. This work assumes, moreover, the goals of an institution that exists to foster critical understanding of the complex process of experiencing and perceiving art.

The 74th American Exhibition, like preceding exhibitions in the series, aims to reflect the present artistic climate. This year the museum is deliberately representing diverse approaches and attitudes at work in our schismatic culture. Inevitably, such a pluralistic exhibition inspires one not only to absorb the many directions being pursued but also to reflect critically upon the artistic process. As this exhibition dramatically demonstrates, contemporary artists continue to embrace, question, or break with the boundaries and conventions of art as they search for new modes of seeing that define the shifting relationships between art and reality—relationships that, finally, insure the validity of a cultural life.

Anne Rorimer
Associate Curator
Department of 20th-Century Painting and Sculpture

Notes

1. See R. Krauss, ''The Originality of the Avant-Garde: A Postmodernist Repetition ,'' *October,* no. 18 (Fall 1981): 47-66. See also ''Post-Modernism,'' a symposium presented by the Young Architects Circle, Institute for Architecture and Urban Studies, N.Y.C., March 30, 1981, published in *REALLIFE Magazine* (Summer 1981): 4-10.
2. For some of the museum exhibitions in which painting is re-examined, see *New Image Painting,* N.Y.C., Whitney Museum of American Art, 1978; *Painting in the 70's,* Buffalo, Albright-Knox Art Gallery, 1978; and *American Painting: The Eighties, A Critical Interpretation,* Grey Art Gallery and Study Center, New York University, 1979. D. Crimp has commented on this recent development in ''The End of Painting,'' *October,* no. 16 (Spring 1981): 69-86.
3. P. Blum, ''A Biographical Note,'' *Robert Moskowitz,* exh. cat., Basel, Basler Kunstverein, 1981: n.p.
4. Letter, M. Bochner to H. Szeeman, dated 1969; cited in *When Attitudes Become Form,* exh. cat., Kunsthalle Bern, 1969: n.p.
5. B. Richardson, *Mel Bochner: Number and Shape,* exh. cat., The Baltimore Museum of Art, 1976: 37.
6. Cited in C. Burnett, ''German Flavor Noted in Peter Dean,'' *The Atlanta Journal* (Jan. 16, 1975): 3-C.
7. The University of California at Los Angeles Extension Program, Department of the Arts, April 5, 1982.
8. Cited in C. Owens, ''Back to the Studio,'' *Art in America* 70 (Jan. 1982): 103.
9. See T. Lawson, ''Last Exit: Painting,'' *Artforum* 19 (Sept. 1981): 39-46.
10. See B. Buchloh, ''Figures of Authority, Ciphers of Regression,'' *October,* no. 16 (Spring 1981): 39-68.
11. *American Painting: The Eighties, A Critical Interpretation* (note 2): n.p.
12. Note 8: 107.
13. Interview by L. Gumpert, *Early Work,* exh. cat., N.Y.C., The New Museum, 1982: 8.
14. J. Belloli, *Image and Object,* exh. cat., The Detroit Institute of Arts, 1980: 21.
15. See M. Wortz, *Larry Bell: New Work,* exh. cat., Yonkers, The Hudson River Museum, 1981: 22.
16. ''Space Division Constructions,'' *James Turrell: Light and Space,* exh. cat., N.Y.C., Whitney Museum of American Art, 1980: 36.
17. *Pictures,* N.Y.C.: Artists Space, 1977: 3.
18. J. Baldessari, cited in *John Baldessari, Works 1966-1981,* exh. cat., Eindhoven, Stedelijk Van Abbemuseum, 1981: 6.
19. Press release, Jancar/Kuhlenschmidt Gallery, L.A., 1982.
20. A. Trachtenberg, ''Camera Work: Notes Toward an Investigation,'' *The Massachusetts Review* (Winter 1978): 843.
21. D. Graham, ''Signs,'' *Artforum* 19 (Apr. 1981): 38-9.
22. ''Concerning PM Magazine by Dara Birnbaum,'' press release, Yonkers, The Hudson River Museum, 1982: 2-3.
23. Unpublished statement.
24. M. Rosler, cited in M. Gever, ''An Interview with Martha Rosler,'' *Afterimage* 9 (Oct. 1981): 14.
25. ''The Work of Art in the Age of Mechanical Reproduction,'' reprinted in *Illuminations,* N.Y.C.: Schocken Books, 1978: 220.
26. Ibid.: 221.
27. ''The Creative Act,'' lecture for the American Federation of the Arts, Houston, 1957, published in *Salt Seller, The Writings of Marcel Duchamp (Marchand Du Sel),* ed. by M. Sanouillet and E. Peterson, N.Y.C.: Oxford University Press, 1973: 140.

John Ahearn
with Rigoberto Torres

1. *Homage to the People of the Bronx:
Double Dutch at Kelly Street I (Frieda,
Jevette, Towana, Stacey),* 1981-82
Oil on fiberglass; 54 x 54 x 12 in.
Casting by John Ahearn and Rigoberto
Torres under supervision of Raul Arce
Lent by Brooke Alexander, Inc.,
New York City

Louis with Bite in Forehead, 1981*
Cast plaster; 24 x 21 x 6 in.
Courtesy Brooke Alexander, Inc.,
New York City
Not in exhibition

(Editor's note: an asterisk [*] indicates
illustration. All dimensions are given
in inches; height precedes width
precedes depth. Texts appearing
within the illustration space were
written or selected by the artists to
illustrate their work. Artists' statements
can be found beginning on page 49.)

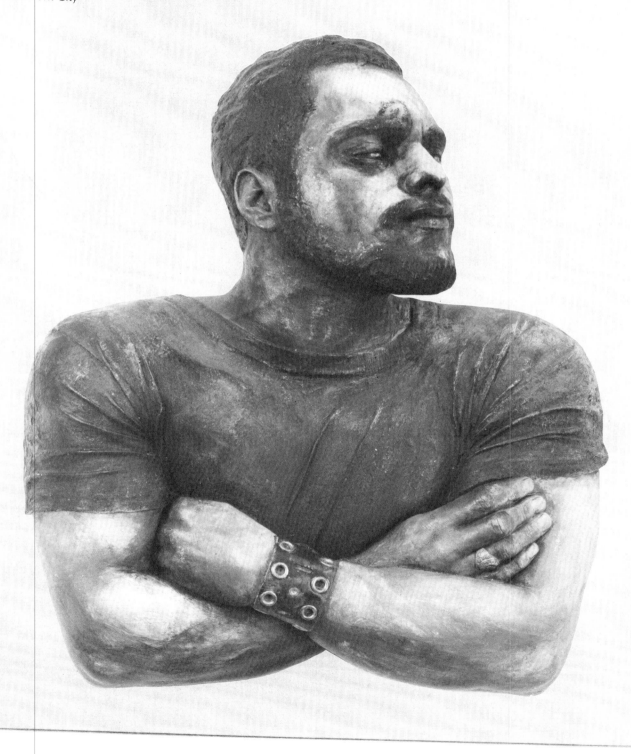

Siah Armajani

2. *Dictionary for Building: Fireplace Mantel,* 1981-82*
Painted wood, mirror, plexiglass;
94 x 92½ x 35½ in.
Lent by Max Protetch Gallery,
New York City

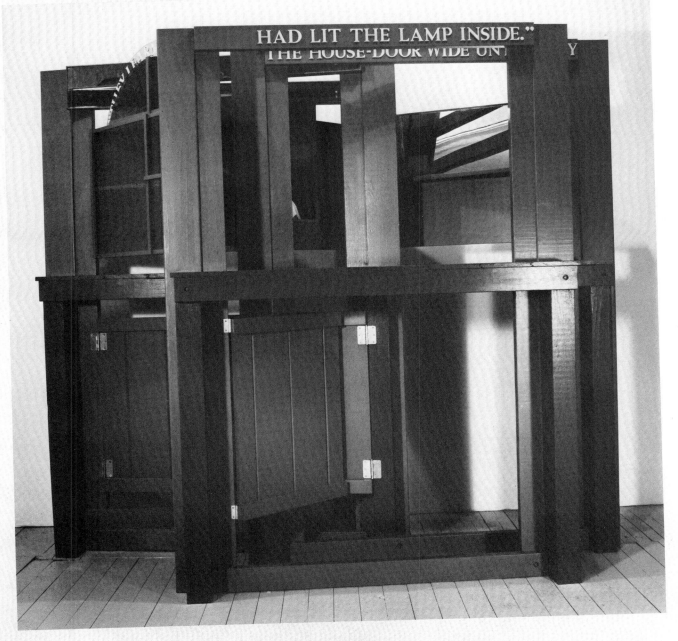

Michael Asher

3. *74th American Exhibition, The Art Institute of Chicago, June 12-August 1, 1982*

The work in this exhibition has been conceived for the Art Institute of Chicago in relation to the museum's permanent collection. It comprises two separate groups of viewers, each consisting of three people, who are viewing two different works of art. The two works viewed are located within the same gallery of the museum and within sight of each other. Of these two works chosen for viewing, one is a work of art that has become familiar to a generalized audience by virtue of extensive reproduction while the other has been less frequently reproduced.

This work is predicated on the dilemma of perceiving original works of art once they have been colored by multiple reproduction in the public domain. One of the most extreme examples is that of the Mona Lisa, which has a superimposed external layer of meaning that intervenes between the original painting and the viewer's first-hand experience of it— an unavoidable factor in the process of perceiving works that have been repeatedly reproduced. Familiarity with a work through second-hand mediation paradoxically serves to interfere with the museum visitor's experience of the original. With regard to works in the museum's permanent collection, this occurs to varying degrees or not at all.

The participating viewers in this work not only draw the museum visitors' attention to two individual works but they also draw their attention to the separate conditions of viewing art as these might be influenced by reproduction. The work intervenes in the full cycle of aesthetic production and cultural reception by incorporating the museum visitors' role and the museum's operation within its own internal structure.

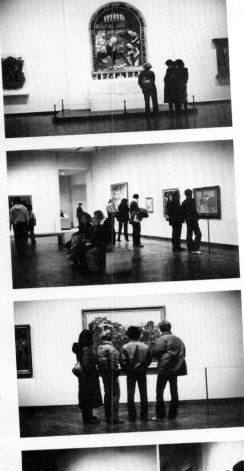

The public viewing the collection, The Art Institute of Chicago.

John Baldessari

4. *Fugitive Essay (with Zebra)*, 1980
Two black and white photographs and
one color photograph; 12¼ x 72¾ in.
(left), 23¼ x 60¼ in. (center), 7¾ x
7¾ in. (right), equally spaced on a wall
240 in. long
Lent by Sonnabend Gallery,
New York City

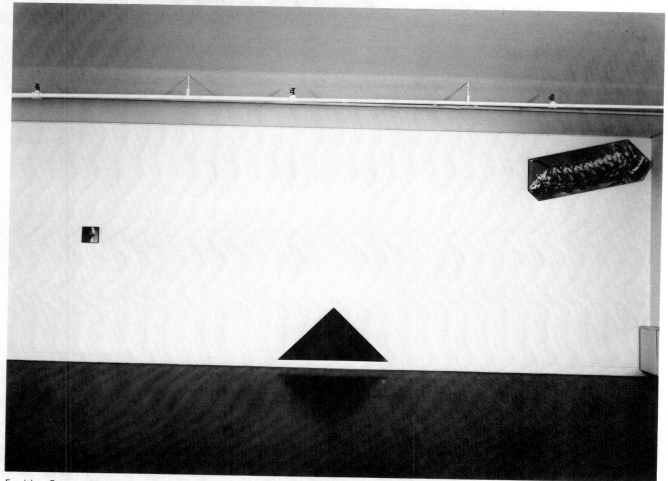

Fugitive Essay, 1980
Two black and white photographs and
one Type C print; 114 x 425 in.
(installation)
Courtesy Sonnabend Gallery,
New York City
Not in exhibition

Larry Bell

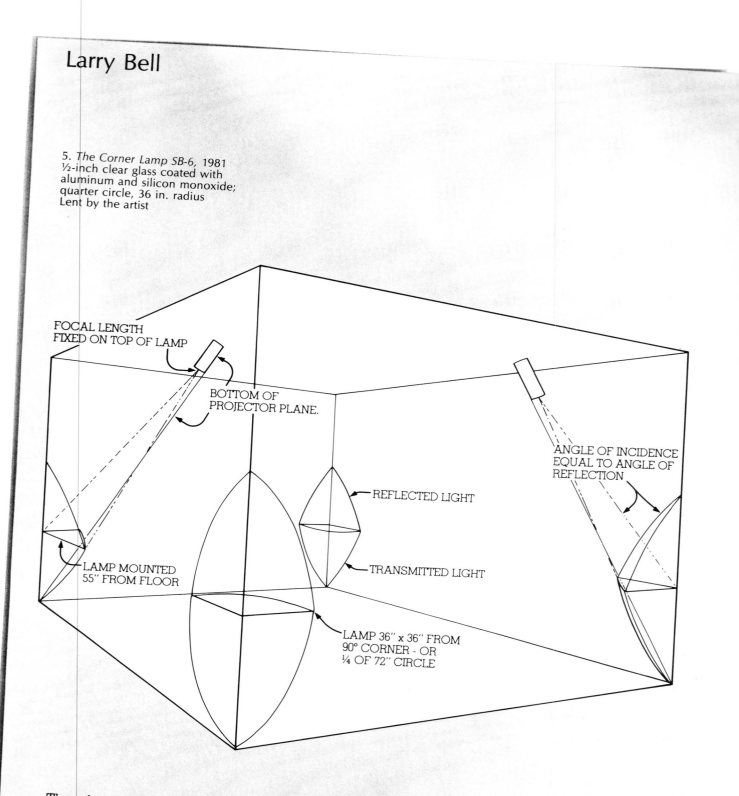

5. *The Corner Lamp SB-6,* 1981
½-inch clear glass coated with
aluminum and silicon monoxide;
quarter circle, 36 in. radius
Lent by the artist

FOCAL LENGTH
FIXED ON TOP OF LAMP

BOTTOM OF
PROJECTOR PLANE.

ANGLE OF INCIDENCE
EQUAL TO ANGLE OF
REFLECTION

REFLECTED LIGHT

TRANSMITTED LIGHT

LAMP MOUNTED
55" FROM FLOOR

LAMP 36" x 36" FROM
90° CORNER - OR
¼ OF 72" CIRCLE

The above diagram shows how the Corner Lamps work. The concept is based on the angle of reflection being equal to the angle of incidence. The Lamps create the ambient light for the Furniture environment.

Each corner has a different set of colors. This mixes as white light in the room. I call them Corner Lamps because the corners become the source of the illumination. The arc reflected and transmitted is a portion of the same ellipse used throughout the environment.

Lynda Benglis

6. *Chakshu,* 1982*
Bronze wire mesh, metalized zinc,
copper and aluminum coating;
32 x 20 x 12 in.
Lent by Paula Cooper Gallery,
New York City

7. *Anandi,* 1982
Bronze wire mesh, metalized zinc,
copper and aluminum coating;
18¼ x 32½ x 10 in.
Lent by Paula Cooper Gallery,
New York City

8. *Kalgi,* 1982
Bronze wire mesh, metalized zinc,
copper and aluminum coating;
22 x 28 x 7 in.
Lent by Paula Cooper Gallery,
New York City

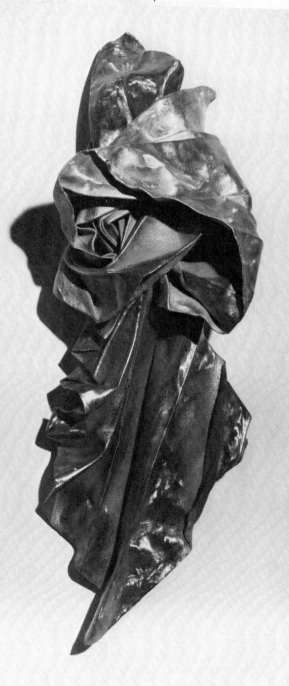

Dara Birnbaum

9. *PM Magazine,* 1982
Video, stereo sound, bromide enlarge-
ment, with speed rail suspension
system, painted walls, and lights;
(installation dimensions can vary)
Lent by the artist

PM Magazine, 1982*
Four-channel video with four-channel
sound, bromide enlargement with
speed rail suspension system, painted
walls, and lights
Installation at the Hudson River
Museum, Yonkers
Not in exhibition

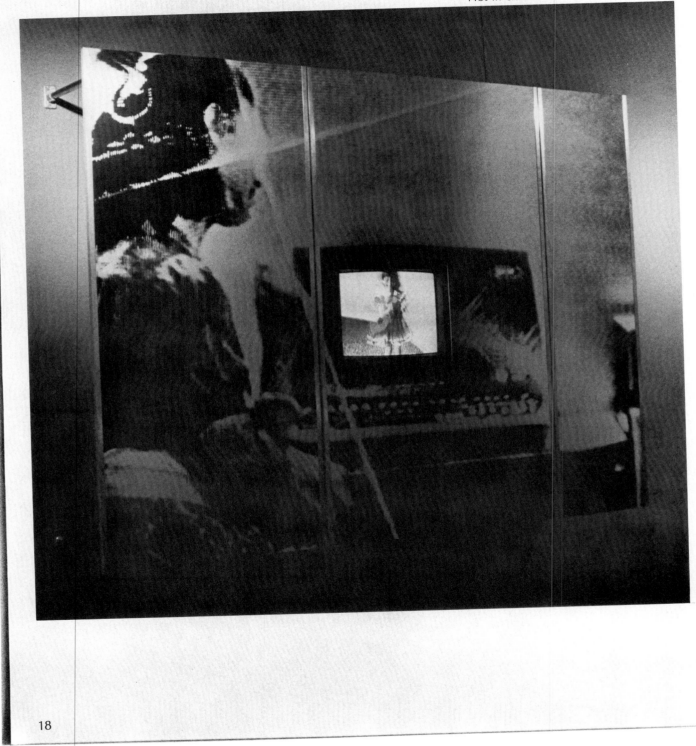

Mel Bochner

10. *Thickness of Time,* 1982*
Charcoal and conte crayon on sized
canvas; 86 x 118 in.
Lent by Mr. and Mrs. S.I. Newhouse,
Jr., New York City

11. *Vertigo,* 1982
Charcoal, conte crayon, and pastel on
sized canvas; 108 x 74 in.
Lent by Sonnabend Gallery,
New York City

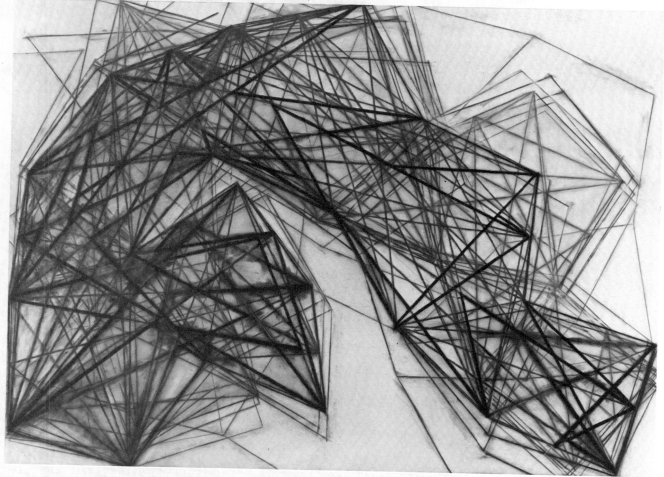

Richard Bosman

12. *Adversaries*, 1981*
Oil on canvas; 72½ x 42 in.
Lent by The Museum of Modern Art,
New York City, fractional gift of
Mr. and Mrs. Carl Lobell, 1982

13. *Death of a Femme Fatale*, 1982
Oil on canvas; 75 x 108 in.
Lent by Brooke Alexander, Inc.,
New York City

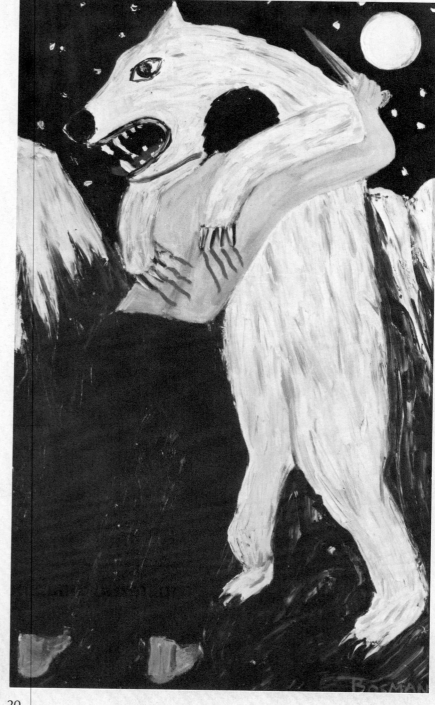

Joan Brown

14. *The Long Journey,* 1981*
Enamel on canvas; 78 x 96 in.
Lent by Allan Frumkin Gallery,
New York City

15. *Hanuman Pillar,* 1981
Enamel on canvas, mounted on wood;
96 in. high
Lent by Allan Frumkin Gallery,
New York City

16. *Ganesha Pillar,* 1981
Enamel on canvas, mounted on wood;
96 in. high
Lent by Allan Frumkin Gallery,
New York City

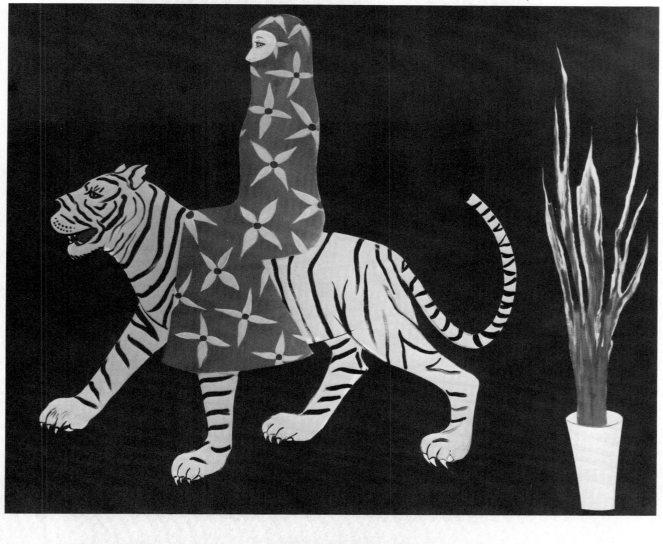

Scott Burton

17. *Aluminum Chair (one of three),* 1981*
Aluminum; 18 x 20 x 48 in.
Lent by Max Protetch Gallery,
New York City

18. *Marble Chair,* 1981
Georgia marble; 50 x 33 x 60 in.
Lent by Mobil Corporation,
New York City

19. *Pedestal Tables, A Pair,* 1982
Copper-plated bronze;
h. 37 in., diam. 11 in.
Lent by Max Protetch Gallery,
New York City

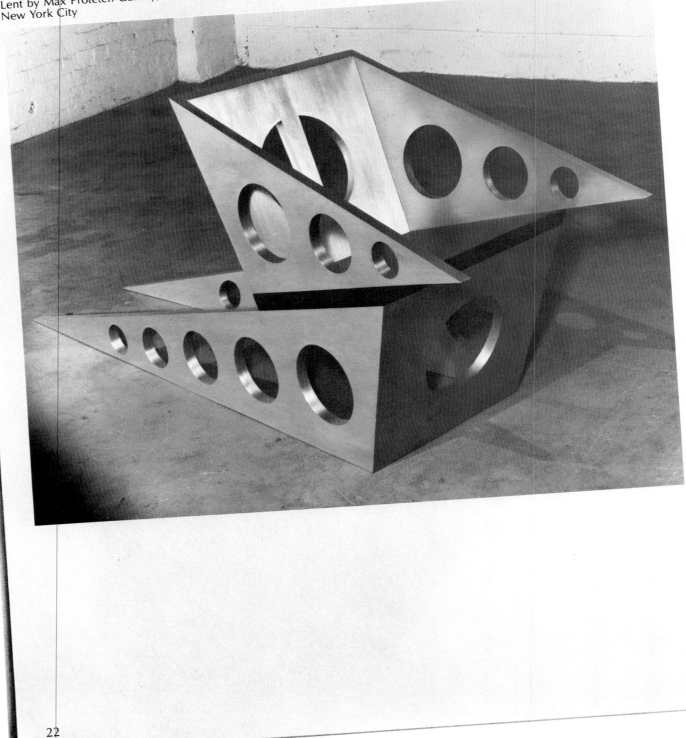

Peter Dean

20. *Don't Touch Me I'm Crazy Horse,*
*1981**
Oil on canvas; 76 x 60 in.
Lent by the artist

21. *Death of Folk Hero,* 1981
Oil on canvas; 72 x 68 in.
Lent by the artist

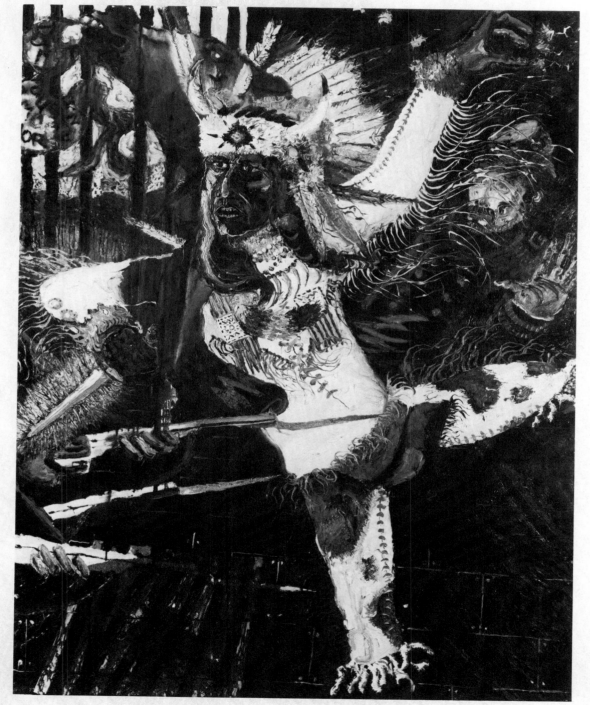

Rafael Ferrer

22. *Junio (Triptych),* 1981*
Oil on canvas; 82 x 101 in.
Lent by Nancy Hoffman Gallery,
New York City

23. *Melida La Reina,* 1981
Oil on canvas; 67 x 94 in.
Sydney and Frances Lewis Collection,
Richmond, Va.

Jack Goldstein

24. *Untitled (MP #50)*, 1981*
Acrylic on canvas; 84 x 132 in.
Lent by Metro Pictures, New York City

25. *Untitled (MP #70)*, 1982
Acrylic on canvas; 96 x 60 in.
Lent by Metro Pictures, New York City

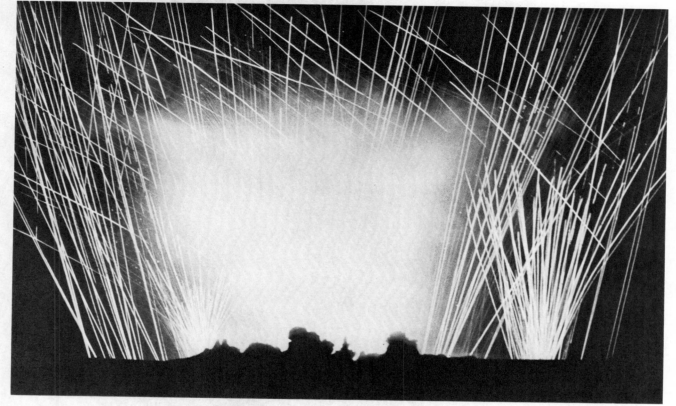

Dan Graham

26. *Pavilion/Sculpture for Argonne,*
*1981**
Wood, plexiglass, and mirrored
plexiglass; 96 x 96 x 96 in.
Lent by the artist

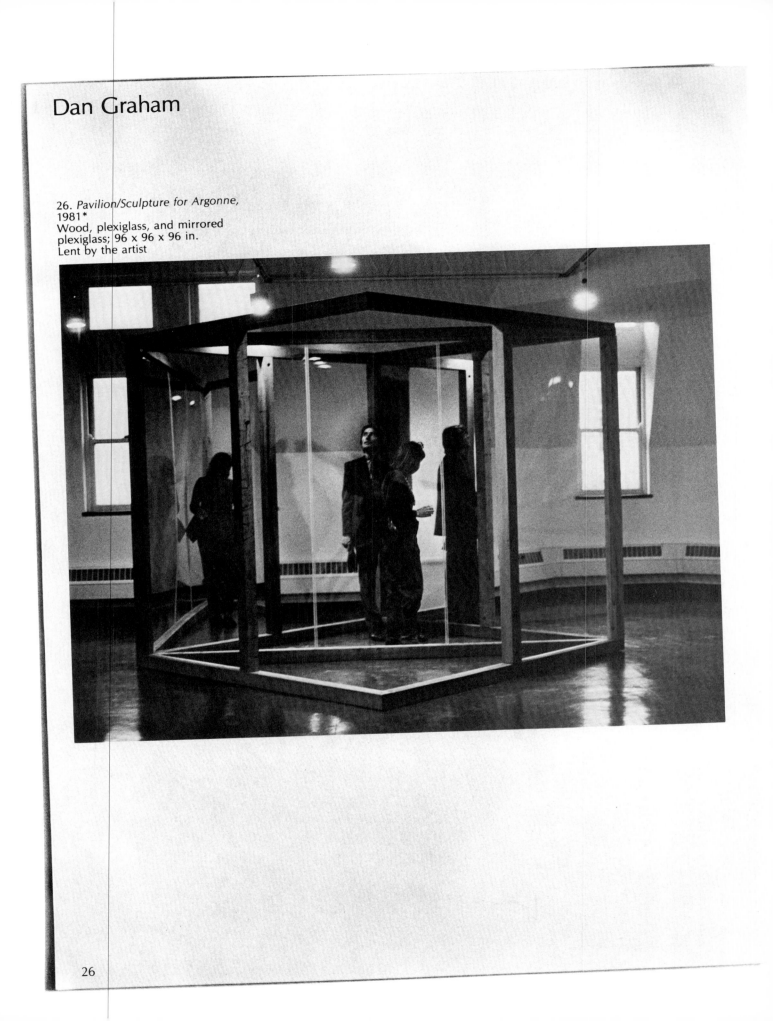

Jenny Holzer

27. *Inflammatory Essays (from the
"Black Book" series), 1979-82 (detail*)*
Offset posters glued to wall; posters:
10 x 10 in. each; (installation
dimensions can vary)
Lent by the artist

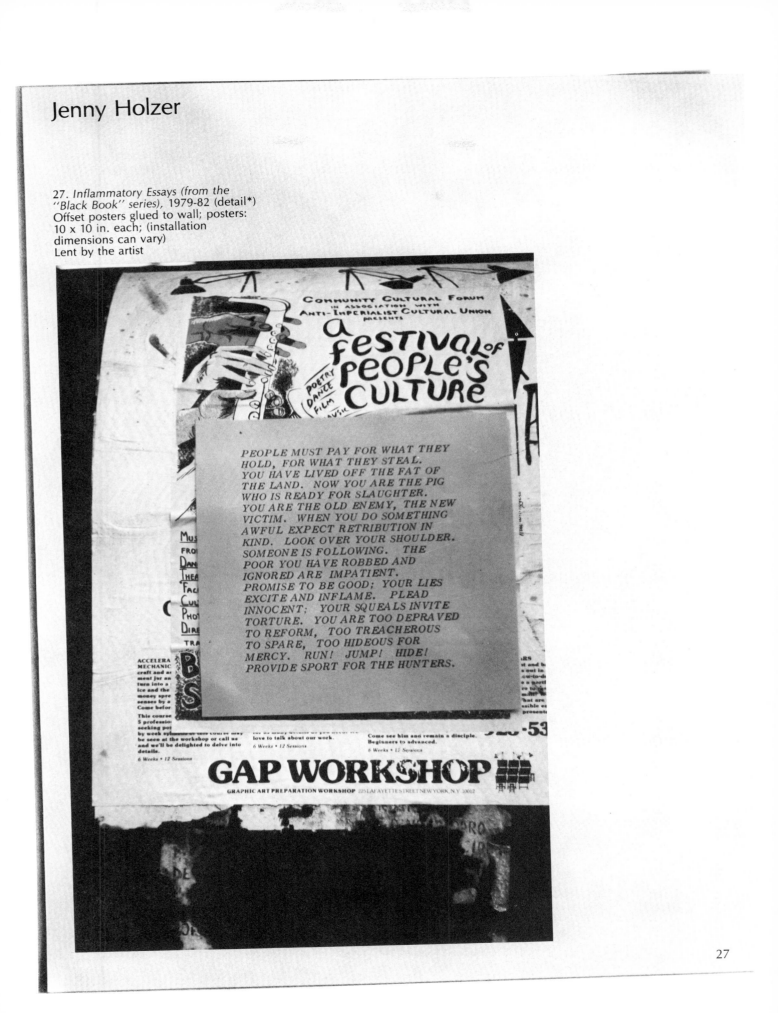

Bryan Hunt

28. *Lafayette Chair,* 1982 (maquette*)
Cast bronze and limestone;
84 x 28 x 28 in. (approx.)
Lent by Blum Helman Gallery,
New York City

29. *Bastion* (third of four), 1981
Cast bronze (black patina) and
limestone; 47 x 32½ x 16 in.
Lent by Blum Helman Gallery,
New York City

30. *Serpentine* (second artist's proof),
1981
Cast bronze (black/gold patina) and
limestone; 30½ x 13 x 8 in.
Lent by the artist

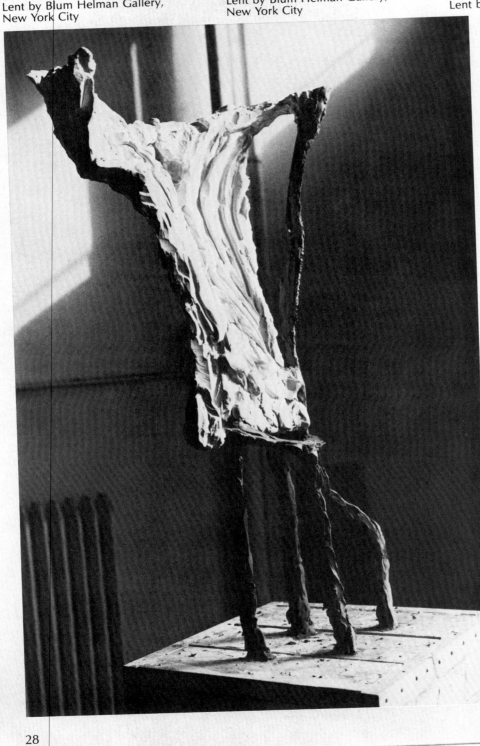

John Knight

31. *Journals Series*, 1978 on

Arizona Highways (Aug. 1980-July 1981)
Lent by Daniel Buren, Paris

Cuisine (May 1981-Feb. 1982)
Lent by India Sandek, Santa Monica, Ca.

Designers West (Jan.-Feb. 1982)
Lent by Germano Celant, Italy

GEO Magazine (June 1980-May 1981)
Lent by Rüdiger Schöttle, Munich

Homes International (Sept./Oct. 1981-Mar./Apr. 1982)
Lent by Asher/Faure Gallery, Los Angeles

1001 Home Decorating Ideas (Jan.-July 1981)
Private Collection, Chicago

Portfolio (May 1981-Apr. 1982)
Lent by Ian Wallace, Vancouver

Revue (Dec. 1981/Jan. 1982)
Lent by Machteld Schrameijer, New York City

Residential Interiors, (May/June-Sept./Oct. 1980) and *Arts & Antiques* (July/Aug.-Sept./Oct. 1981)
Lent by Coosje van Bruggen and Claes Oldenburg, New York City

Town and Country (Dec. 1980-Nov. 1981)
Lent by John Vinci, Chicago

Tear sheet, furniture advertisement from *Abitare* (Sept. 1981)

Barbara Kruger

32. *Untitled (Your manias become science)*, 1982
Photograph; 40 x 50 in.
Lent by the artist

33. *Untitled (You have searched and destroyed)*, 1982
Photograph; 40 x 50 in.
Lent by the artist

34. *Untitled (You thrive on mistaken identity)*, 1982
Photograph; 60 x 40 in.
Artist's copy of original in collection of Thomas Amman, Zurich; courtesy Larry Gagosian Gallery, Los Angeles

35. *Untitled (I am your slice of life)*, 1982*
Photograph; 60 x 40 in.
Artist's copy of original in collection of Ira Young, West Vancouver; courtesy Larry Gagosian Gallery, Los Angeles

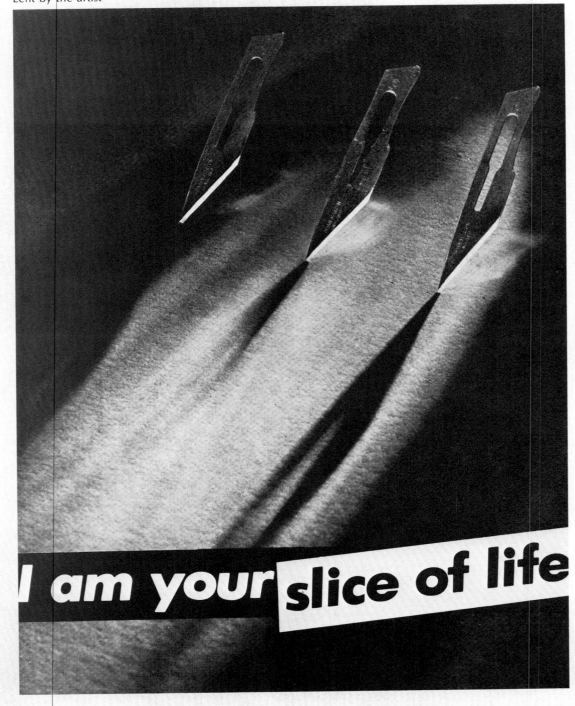

Sherrie Levine

36. *After Franz Marc,* 1982 (detail*)
Six offset color lithographs; 31 x 23
in., 29 x 18½ in., 21 x 17½ in., 19½ x
15½ in., 21 x 27½ in., 25 x 25 in.
(installation dimensions can vary)
Lent by the artist

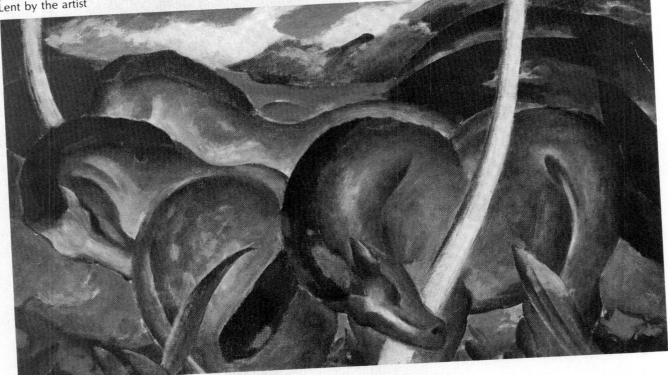

Sol LeWitt

37. *On a white wall, isometric drawings of three geometric figures using three tones of india ink wash, 1981*
India ink on white wall; (all figures based on isometric square of 88 in.) cube: 132 x 88 in., pyramid: 110 x 88 in., trapezoid: 117½ x 88 in.

Drawn by Anthony Sansotta
Lent by John Weber Gallery, New York City, and Young-Hoffman Gallery, Chicago

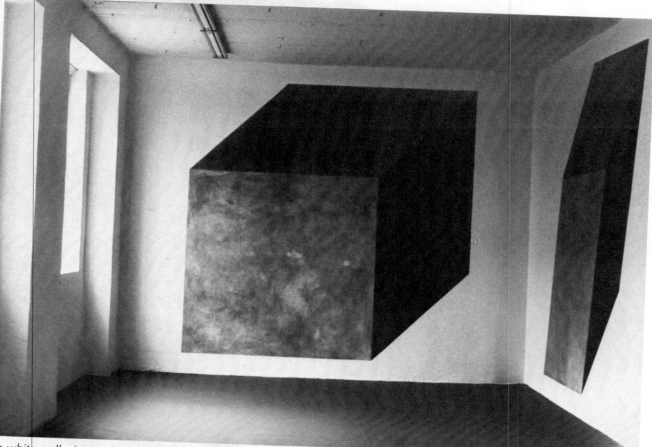

On white walls, isometric drawings of six geometric figures using three tones of india ink wash, 1981 (detail)*
Drawn by Sol LeWitt and Carol Androccio
Installation at Konrad Fischer Gallery, Düsseldorf
Not in exhibition

Robert Mangold

38. *Painting for Three Walls,* 1979*
Acrylic and graphite on canvas;
three panels, 96 x 128 in. each
Lent by John Weber Gallery,
New York City, and Young-Hoffman
Gallery, Chicago

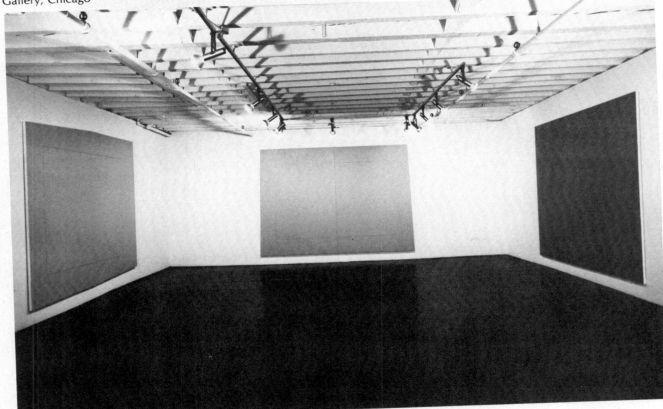

Robert Moskowitz

39. *The Seventh Sister,* 1981
Oil on canvas; 108 x 39 in.
Lent by the artist

40. *Copperhead,* 1981
Oil on canvas; 108 x 38 in.
Lent by the artist

41. *Black Mill,* 1981*
Oil on canvas; 108 x 63 in.
Lent by the artist

Elizabeth Murray

42. *Back on Earth,* 1981*
Oil on canvas; 120½ x 135 in.
Lent by Paula Cooper Gallery,
New York City

43. *Yikes,* 1982
Oil on canvas; 116 x 113 in.
Lent by Douglas S. Cramer,
Los Angeles

Bruce Nauman

44. *Diamond Africa With Tuned Chair,*
D, E, A, D, 1981*
Steel and cast iron; 60 x 285 x 138¼ in.
Lent by Leo Castelli Gallery and Sperone
Westwater Fischer, New York City

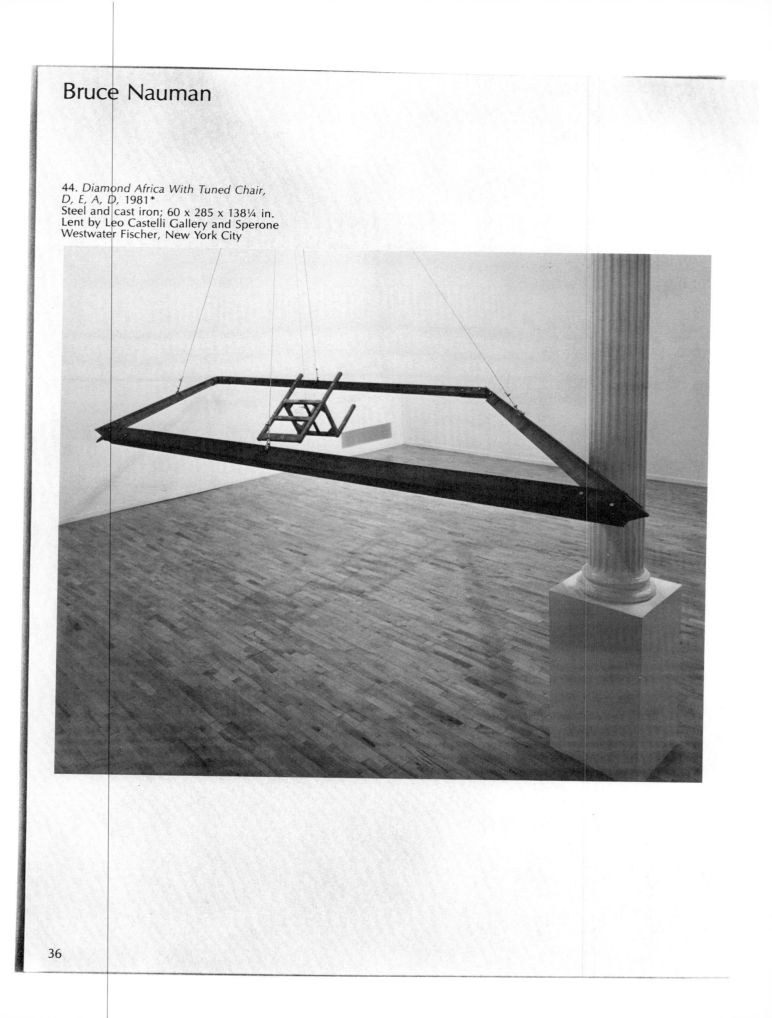

Katherine Porter

45. *San Salvador*, 1980*
Oil on canvas; 79½ x 142¾ in.
Lent by David McKee Gallery,
New York City

Stephen Prina

46. *Aristotle-Plato-Socrates*, 1982
(details*)
Mixed media installation; two color
photographs: 56½ x 53¾ in., 51 x
77¼ in., three black and white photo-
graphs: 9½ x 6½ in. each, three
mounted audio tapes: 8¼ x 28½ in.,
8¼ x 58½ in., 8¼ x 62¼ in.
(installation dimensions can vary)
Lent by the artist

Aristotle
384-322 B.C.
Plato is dear to me, but dearer still
is truth.

Rembrandt van Rijn
1606-1669
*Aristotle Contemplating the Bust of
Homer*, 1653. Oil on canvas; 56½
x 53¾ in. The Metropolitan Museum
of Art, New York City. Purchased with
Special Funds and Gifts of Friends of
the Museum, 1961.

Plato
c. 429-347 B.C.
Socrates is charged with corrupting
the youth of the city, and with
rejecting the gods of Athens and
introducing new divinities.

Socrates
469-399 B.C.
The hour of departure has arrived,
and we go our ways—I to die, and
you to live. Which is the better,
God only knows.

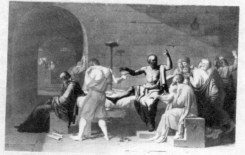

Jacques Louis David
1748-1825
The Death of Socrates, 1787.
Oil on canvas; 51 x 77¼ in. The
Metropolitan Museum of Art, New
York City. Wolfe Fund, 1931.

Martin Puryear

47. *Sanctuary*, 1982
Wood, mixed materials; 126 x 24 x 18 in.
Lent by the artist; courtesy
Young-Hoffman Gallery, Chicago

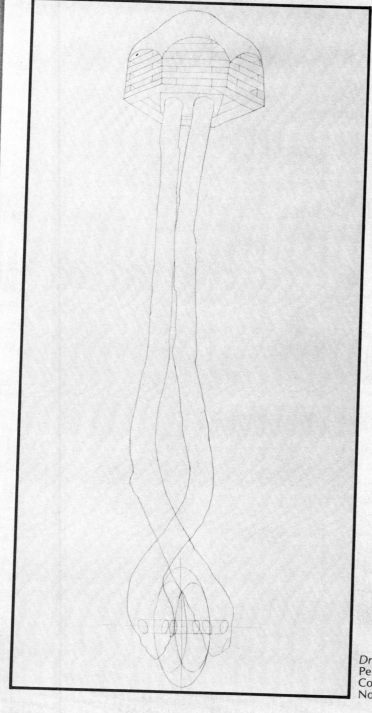

Drawing for "Sanctuary," 1982
Pencil on vellum
Courtesy of the artist
Not in exhibition

Martha Rosler

48. *Losing: A Conversation with the Parents,* 1977
Color video; 20 mins.
Lent by the artist

49. *The East is Red, The West is Bending,* 1977 (detail*)
Color video; 20 mins.
Lent by the artist

50. *Secrets from the Street: No Disclosure,* 1980
Color video; 10 mins., 45 secs.
Lent by the artist

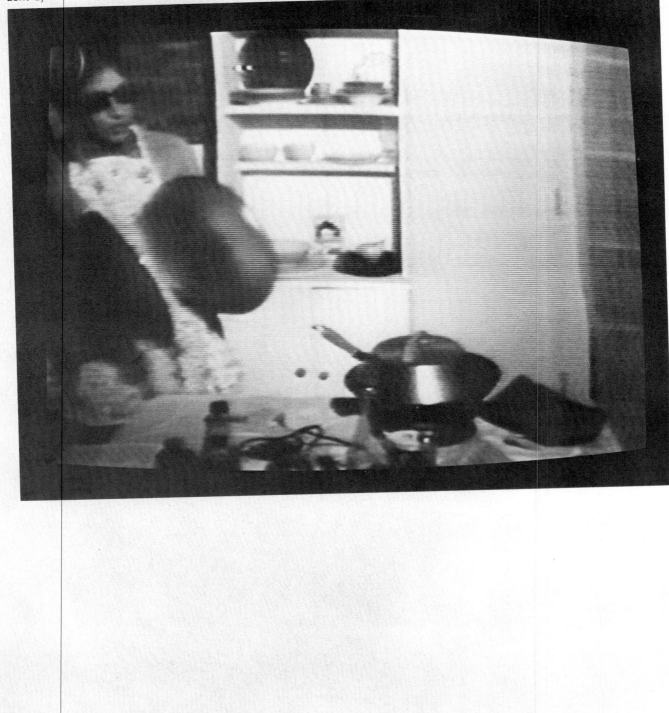

Susan Rothenberg

51. *Wishbone,* 1979
Acrylic and flashe on canvas;
102 x 76 in.
Private Collection

52. *Blue-Body,* 1980-81*
Acrylic and flashe on canvas;
108 x 75 in.
Collection of Eli and Ethyl L. Brode,
Los Angeles; courtesy Willard Gallery,
New York City

David Salle

53. *The Old, the New, and the Different*, 1981*
Acrylic on canvas; 96 x 150 in.
Lent by Janet and Michael Green,
London; courtesy Mary Boone/
Leo Castelli, New York City

Julian Schnabel

54. *Voltaire*, 1981*
Oil and mixed media on wood;
84 x 168 in.
Collection of Mary Boone; courtesy
Mary Boone/Leo Castelli, New York City

55. *Untitled Painting in a Snow Storm*,
1982
Oil on velvet and rug batting;
96 x 132 in.
Collection of Mary Boone; courtesy
Mary Boone/Leo Castelli, New York City

Joel Shapiro

56. *Untitled,* 1982
Cast bronze; 11½ x 17½ x 10⅛ in.
Lent by Paula Cooper Gallery,
New York City

57. *Untitled,* 1982
Wood and oil paint;
12⅜ x 43¼ x 13¼ in.
Lent by Paula Cooper Gallery,
New York City

58. *Untitled* (first of three), 1982*
Cast bronze; 23¾ x 13 x 8⅛ in.
Lent by Paula Cooper Gallery,
New York City

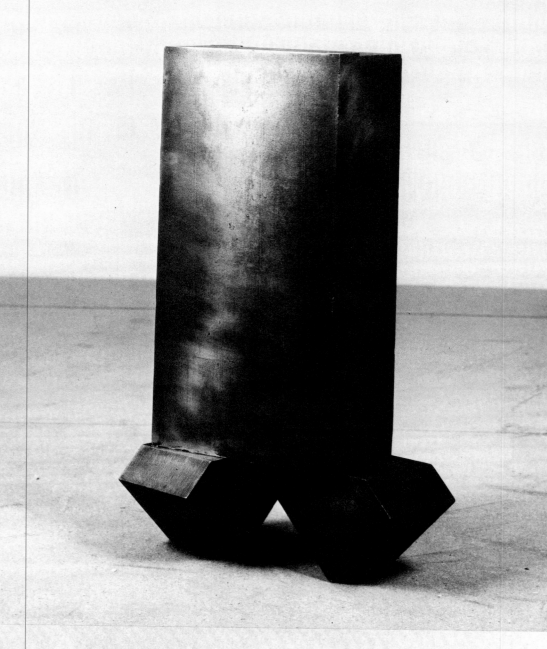

James Turrell

59. *Rayna,* 1979*
Wood framing, sheet rock, wood;
room size: 193 x 408 x 312 in.
(outside), 177 x 408 x 144 in. (inside)
Fabricated by Craig Baumhofer,
CONSTRUCTART, Seattle
Lent by the artist

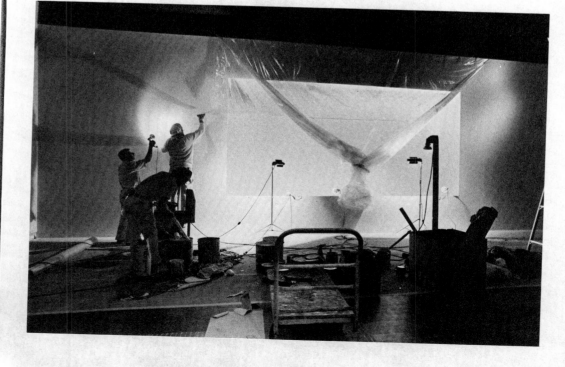

Richard Tuttle

60. *Untitled 1 through 14*, 1982
Framed gouaches on paper, museum
mount board, wood, paint, metal
wire, and nails; 9½ x 14 x 1½ in. each
Lent by the artist

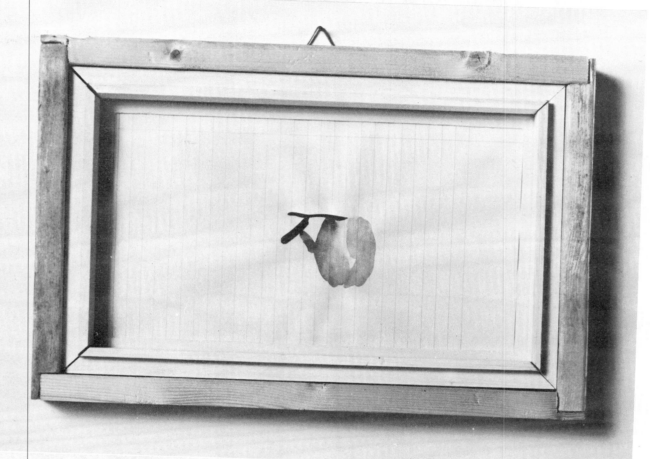

Untitled, 1981 (detail*)
Framed gouache; 9½ x 14 x 1½ in.
Collection of Mr. and Mrs. E.H.
Brunner, Switzerland
Not in exhibition

Christopher Williams

61. *Source, The Photographic Archive,*
*John F. Kennedy Library...,*1981-82
Color and black and white
photographs, text; (installation
dimensions can vary)
Lent by the artist

Ray Yoshida

62. *Fitting Handful*, 1982*
Acrylic on canvas; 36 x 50 in.
Lent by Gladys Nilsson and Jim Nutt,
Wilmette, Ill.

63. *In Touch With*, 1982
Acrylic on canvas; 38 x 50 in.
Lent by Phyllis Kind Gallery, Chicago
and New York City

64. *Touch and Go*, 1980-81
Acrylic on canvas; 38¼ x 50 in.
Lent by Mr. and Mrs. Edwin A.
Bergman, Chicago

Artists' Statements and Bibliographies

(Editor's note: The statements appearing at the beginning of the following bibliographies were written specifically or selected by the artists for inclusion in this catalogue. Some of the artists preferred not to include any statement. We are grateful to the artists and their representatives for providing us with material from which we selected the information comprising the following documentation. Abbreviations used below include: L.A., Los Angeles; N.Y.C., New York City; S.F., San Francisco.)

John Ahearn

Born in Binghamton, New York, 1951
Lives in New York City

Selected Group Exhibitions:
591 Broadway, N.Y.C., "Dog Show," 1978, and "Doctors and Dentists Show," 1979; 5 Bleecker Street, N.Y.C., "Money Show" and "Manifesto Show," 1979; N.Y.C., "The Times Square Show," 1980; New Museum, N.Y.C., "Events: Fashion Moda," 1980; Lisson Gallery, London, 1980; Brooke Alexander, Inc., N.Y.C., "Collaborative Projects Presents a Benefit Exhibition," 1980, and "Represent, Representation, Representative," 1981; Museen der Stadt Köln, "Heute: West-kunst," 1981; Semaphore Gallery, N.Y.C., "The Anxious Figure," 1981; Albright-Knox Art Gallery, Buffalo, "Figures, Forms and Expressions," 1981; Young-Hoffman Gallery, Chicago, 1982.

Selected Bibliography:
W. Robinson, "John Ahearn at Fashion/Moda," *Art in America* 68 (Jan. 1980): 108; C. Rickey, "John Ahearn, The New Museum Windows," *Artforum* 18 (Mar. 1980): 75; R. Armstrong, "Heute: West-kunst," *Artforum* 20 (Summer 1981): 85-6; R. Ricard, "The Radiant Child," *Artforum* 20 (Dec. 1981): 38-9, 43.

Siah Armajani

Born in Teheran, Iran, 1939
Lives in Minneapolis, Minnesota

To build open, available, useful, low, near, common public gathering places. Not as a thing between four walls in a geometric spatial sense but as a tool which directs us into a place for living, sitting, resting, reading, eating, and talking.

Selected One-Person Exhibitions:
Henry Gallery, University of Washington, Seattle, 1972; Clocktower, Institute for Art and Urban Resources, N.Y.C., 1974; Wright State University, Dayton, 1977; Moore College of Art, Philadelphia, 1977; University of Kentucky, Lexington, 1977; Philadelphia College of Art, 1978; Max Protetch Gallery, N.Y.C., 1979; Ohio State University, Columbus, 1979; Contemporary Arts Center, Cincinnati, 1980; Joslyn Art Museum, Omaha, 1980; Hudson River Museum, Yonkers, 1980; Baxter Art Gallery, California Institute of Technology, Pasadena, 1982.

Selected Group Exhibitions:
Museum of Contemporary Art, Chicago, "Art by Telephone" and "Towers," 1969; Indianapolis Museum of Art, "Painting and Sculpture Today," 1969; Museum of Modern Art, N.Y.C., "Information," 1970; Minnesota State Arts Council, Minneapolis, "9 Artists/9 Spaces," 1970; University of Montana, Missoula, "Architectural Entities," 1970; Walker Art Center, Minneapolis, "Works for New Spaces" and "Drawings, 10 Minnesota Artists," 1971, "Scale & Environment: 10 Sculptors," 1977; Institute of Contemporary Arts, London, "Unlikely Photograpy," 1971; Kassel, "Documenta," 1972, 82; Federal Center, Chicago, "Sculpture for a New Era," 1975; Carpenter Center for the Visual Arts, Harvard University, Cambridge, "Virtual Reality," 1976; University Art Museum, Berkeley, 1976; Solomon R. Guggenheim Museum, N.Y.C., "Young American Artists: 1978 Exxon National Exhibition"; Whitney Museum of American Art, N.Y.C., "Architectural Analogues" (Downtown), 1978, and "1981 Biennial Exhibition"; Max Protetch Gallery, N.Y.C., "Inaugural Exhibition," 1978, and "Works on Paper," 1980; Institute of Contemporary Art of the University of Pennsylvania, Philadelphia, "Dwellings," 1978, and "Drawings: The Pluralist Decade," 1980; Weatherspoon Art Gallery, University of North Carolina, Greensboro, "Art on Paper," 1979; Protetch-McIntosh Gallery, Washington, D.C., "Art & Architecture, Space & Structure," 1979; Wave Hill Environmental Center and Sculpture Gardens, Bronx, "Wave Hill: The Artist's View," 1979; "39th Venice Biennale," 1980; Los Angeles Institute of Contemporary Art, "Architectural Sculpture," 1980; XIII Winter Olympic Games, Lake Placid, "Environmental Art," 1980.

Selected Bibliography:
Siah Armajani: Red School House for Thomas Paine, catalogue of exhibition organized by the Philadelphia College of Art, 1978 (text by J. Kardon, statement and notes by S. Armajani); R. Pincus-Witten, "Siah Armajani: Populist Mechanics," *Arts Magazine* 53 (Oct. 1978): 126-8; R. Berlind, "Armajani's Open-Ended Structures," *Art in America* 67 (Oct. 1979): 82-5; *Siah Armajani: Reading Garden #2,* catalogue of exhibition organized by the Joslyn Art Museum, Omaha, 1980 (text by H.T. Day); J. Merkel, "Siah Armajani, Contemporary Arts Center, Cincinnati," *Artforum* 19 (Mar. 1981): 89-90.

Michael Asher

Born in Los Angeles, California 1943
Lives in Venice, California

Selected One-Person Exhibitions:
La Jolla Museum of Contemporary Art, 1969; Gladys K. Montgomery Art Center, Pomona College, Ca., 1970; Market Street Program, Venice, Ca. 1972; Gallery A-402, California Institute of the Arts, Valencia, 1973; Project Inc., Cambridge School, Weston, Ma., 1973; Lisson Gallery, London, 1973; Galerie Heiner Friedrich, Cologne, 1973; Galleria Toselli, Milan, 1973; Claire S. Copley Gallery, L.A., 1974; Anna Leonowens Gallery, Nova Scotia College of Art and Design, Halifax, 1974; Otis Art Institute of Parsons School of Design, L.A., 1975; Clocktower, Institute for Art and Urban Resources, N.Y.C., 1976; Floating Museum, S. F., 1976; Claire S. Copley Gallery, L.A., and Morgan Thomas Gallery, Santa Monica, 1977; Stedelijk Van Abbemuseum, Eindhoven, 1977; Museum of Contemporary Art, Chicago, 1979; Corps de Garde, Groningen, 1979.

Selected Group Exhibitions:
Los Angeles County Museum of Art, "I am Alive," 1967, "24 Young Los Angeles Artists," 1971, "Ten Years of Contemporary Art Council Acquisitions," 1972, "Seventeen Artists in the Sixties, The Museum as Site: Sixteen Projects," 1981; Lytton Gallery of Visual Arts, L.A., "Mini Things," 1968; Art Gallery, University of California, San Diego, "New Work/Southern California," 1968; Portland Art Museum, Or., "West Coast Now," 1968; San Francisco Art Institute, "18'6" x 6'9" x 11'2½" x 47' x 11³⁄₁₆" x 29'8½" x 31' 9³⁄₁₆"," 1969; Newport Harbor Art Museum, Newport Beach, Ca., "The Appearing/Disappearing Image/Object," 1969; Whitney Museum of American Art, N.Y.C., "Anti-Illusion: Procedures/Materials," 1969; Pavilion of the Seattle Art Museum, "557,087," 1969; Kunsthalle Bern, "Pläne und Projekte als Kunst/Plans and Projects as Art," 1969; Museum of Modern Art, N.Y.C., "Spaces," 1969; Allen Memorial Art Museum, Oberlin College, "Art in the Mind," 1970; Kassel, "Documenta," 1972, 82; New York Cultural Center, "3D into 2D: Drawings for Sculpture," 1973; Pasadena Museum of Modern Art, "The Betty and Monte Factor Family Collection," 1973; Gallery 167, University of California, Irvine, "Recent Works," 1973; La Jolla Museum of Contemporary Art, "University of California, Irvine, 1965-75," 1975; Portland Center for the Visual Arts, Or., "Via Los Angeles," 1976; San Francisco Museum of Modern Art, "Painting and Sculpture in California: The Modern Era," 1976; "37th Venice Biennale: Ambiente Arte," 1976; Los Angeles Institute of Contemporary Art, "Michael Asher, David Askevold, Richard Long," 1977; California Institute of the Arts, Valencia, "Faculty Exhibition,"

1977; Westfälisches Landesmuseum für Kunst und Kulturgeschichte, Munster, "Skulptur," 1977; Fort Worth Art Museum, "Los Angeles in the Seventies," 1977; Joslyn Art Museum, Omaha, "Los Angeles in the Seventies," 1979; Art Institute of Chicago, "73rd American Exhibition," 1979; Université de Québec à Montréal, 1980; Museen der Stadt Köln, "Heute: Westkunst," 1981; Banff Center for Continuing Education, Alberta, "Vocation/Vacation," 1981; Krefelder Kunstmuseen, "Michael Asher/Daniel Buren," 1982.

Selected Bibliography:
Michael Asher, David Askevold, Richard Long, catalogue of exhibition organized by Los Angeles Institute of Contemporary Art, 1977 (text by D. Cypis, F. Dolan, and T. Jimmerson); M. Asher, B.H.D. Buchloh, R. Fuchs, *Michael Asher: Exhibitions in Europe 1972-1977*, Eindhoven: Stedelijk Van Abbemuseum, 1980; A. Rorimer, "Michael Asher: Recent Work," *Artforum* 18 (April 1980): 46-50; *Michael Asher: Work 1967-1978*, Press of the Nova Scotia College Art and Design, Halifax: (at press; extensive bibliog.).

John Baldessari

Born in National City, California, 1931
Lives in Santa Monica, California

Fugitive Essays
The wall is divided vertically (by pencil) into three equal modules. Each module has three zones.

The top zone is for the irregular pieces. They are always pushing out of a top corner of the module and situated on a diagonal running to the opposite bottom corner of the wall. It is in black and white to equal foreboding, anxiety, the irrational, Dionysian, chaotic, unexplored... thus, the choice of subject matter. The subject matter is closely cropped and determines the particular shape of the frame (no surrounding space, suffocating).

The middle zone of the module is for the regular pieces. They are either color or black and white. They are always situated at eye level and directly in the center of the module. The subject matter is classic, salon-type photography and the scale is ordinary, normal photographic size. The intent is a conventional look.

The bottom zone of the module is for large; but regular pieces. They are always at floor level and either left, center or right. They are in black and white or in color. As was stated, the scale goes beyond the regular, but they are classic, geometric shapes. Here, however, circles and triangles are allowed. And the subject matter is determined by the frame. The intent is spaciousness, symmetry, the Apollonian, peacefulness, cerebral, control, reason, passiveness, and etc.

Fugitive Essay—As a literary term. Fugitive to mean temporary discourse. An essay that is not the final word on a subject. But also here to mean; FUGITIVE (escape) ESSAYS (attempts)

In Modern Poetry:
The Imagists—The present, alive, revolutionary impulse, unexpressed possibilities.

The Fugitives—The past, tradition, the deliberate. Fugitive equals emergent

equals modern man equals loneliness as a permanent human condition. A sense of regionalism in time, space, etc. "Deliberate Exiles," "Weary Nomads."

Thus, essays on escape. Attempts to explain various needs to escape. A literary term since these are visual poems. Also, somewhat a tribute to the Fugitive Poets as regionalists, traditionalists, classicists, and their quarreling about aesthetic attitudes as well as escape from them.

The three pieces on each wall should be seen in dialogue. They begin with the normal piece, go from there to the quasi-normal, and thence to the oddly irregular piece. Primarily the meaning comes from scale, placement, and color relationships. The content of the photographs gives meaning as well, but more from the nature of what is pictured than specifically what is there. That is, that a rhino is pictured because it is threatening imagistically and not because it is a rhino per se. Whatever meaning is produced from the collision of a rhino, an eggplant, and draped electrical wire, for instance, will be a personal one. Form and content are welded and the meaning intended is a quarrel, a dialogue, as stated above.

Selected One-Person Exhibitions:
La Jolla Museum of Art, 1960, 66; Southwestern College, Chula Vista, Ca., 1962, 64, 75; Eugenia Butler Gallery, L.A., 1970; Galerie Konrad Fischer, Dusseldorf, 1971, 73; Art and Project, Amsterdam, 1971-72, 74; Nova Scotia College of Art and Design, Halifax, 1971; Galerie MTL, Brussels, 1972, 75; Galleria Toselli, Milan, 1972, 74; Jack Wendler Gallery, London, 1972, 74; Sonnabend Gallery, N.Y.C., 1973, 75, 78, 80-81; Galerie Sonnabend, Paris, 1973, 75; Galleria Schema, Florence, 1973; Galerie Skulima, Berlin, 1974; Stedelijk Museum, Amsterdam, 1975; University of Akron, 1976; Ohio State University, Columbus, 1976; Experimental Art Foundation, Adelaide, 1976; Institute of Modern Art, Brisbane, 1976; Institute of Contemporary Art, Sydney, 1976; Wadsworth Atheneum, Hartford, 1977; Foundation for Art Resources, Fox Venice Theater, Ca., 1977; Portland Center for the Visual Arts, Or., 1978; Theater Vanguard, L.A., 1978; Pacific Film Archives, Berkeley, 1978; Whitney Museum of American Art, N.Y.C., 1978; Institute of Contemporary Art, Boston, 1978; Halle für Internationale Neue Kunst, Zurich, 1979; New Museum, N.Y.C., 1981; Stedelijk Van Abbemuseum, Eindhoven, 1981; CEPA Gallery, Buffalo, 1981; Albright-Knox Art Gallery, Buffalo, 1981; Rüdiger Schöttle Gallery, Munich, 1981; Folkwang Museum, Essen, 1981.

Selected Group Exhibitions:
Museum of Contemporary Art, Chicago, "Art by Telephone," 1969, and "A View of A Decade," 1977; Whitney Museum of American Art, N.Y.C., "Annual Exhibition," 1969, "Biennial Exhibition," 1972, 77, 79, "Words" (Downtown), 1977, "Art About Art," 1978; Städtisches Museum, Leverkusen, "Konzeption-Conception," 1969; Galleria Civica d'Arte Moderna, Turin, "Conceptual Art/Arte Povera/Land Art," 1970; Museum of Modern Art, N.Y.C., "Information," 1970, "Pier 18," 1971; "California Prints," 1972,

"Projects: Video," 1975; Vancouver Art Gallery, "955,000: Conceptual Art," 1970; Museo de Arte Moderno de Buenos Aires, "Systems Art," 1971; Contemporary Arts Museum, Houston, "5 Artists" and "Video Tapes," 1972, "American Narrative/Story Art: 1967-1977," 1978; Kassel, "Documenta," 1972, 82; Kunstmuseum Basel, "Konzept-Kunst," 1972; Nova Scotia College of Art and Design, Halifax, "First 8mm International Film Festival," 1972; Everson Museum of Art, Syracuse, "Circuit: New Works on Videotape," 1973; Zagreb, "International Manifestation t-5," 1973; Art Institute of Chicago, "Idea and Image in Recent Art," 1974; Heidelberger Kunstverein, "Demonstrative Fotografie," 1974; Kunsthalle Köln, "Photokina," 1974; Long Beach Museum of Art, "Southland Video Anthology," 1974, and "Americans in Florence/ Europeans in Florence: Art/Tapes/22," 1975; Contemporary Arts Gallery, New York University, "First New York City Postcard Show," 1975; Konsthall Malmö, "New Media," 1975; Detroit Institute of Arts, "American Artists: A New Decade," 1976; Gallery D, University of California, Berkeley, "Video," 1976; Center for Photographic Art, La Jolla, "Photography as Means," 1977; Los Angeles Institute of Contemporary Art, "Artworks and Bookworks," 1978; Institute of Contemporary Art, Boston, "Narration" and "Wit and Wisdom: Works by Baldessari, Hudson, Levine and Oppenheim," 1978; P.S.1, Institute for Art and Urban Resources, Long Island City, "Altered Photography," 1979; Santa Barbara Museum of Art, "Attitudes," 1979; Dartmouth College Museum and Galleries, Hanover, "Narrative Art," 1979; Herbert F. Johnson Museum of Art, Cornell University, Ithaca, "New Aspects of Self in American Photography," 1979; Bonner Kunstverein, "Text-Photo-Geschichten," 1979; Hayward Gallery, London, "Pier & Ocean," 1980; Visual Studies Workshop, Rochester, N.Y., "Visual Articulation of Idea," 1980; Fine Arts Gallery, University of California, Irvine, "Situational Imagery," 1980; Folkwang Museum, Essen, "Departure from the Single Image," 1980; Los Angeles County Museum of Art, "The Museum as Site: Sixteen Artists," 1981; Museen der Stadt Koln, "Westkunst," 1981; Wiener Secession, "Extended Photography, 5th International Biennial," 1981; Stedelijk Museum, Amsterdam, "Instant Photography," 1981; Art Gallery of New South Wales, Sydney, "Biennale of Sydney," 1982.

Selected Bibliography:
John Baldessari: Work 1966-1980, catalogue of exhibition organized by the New Museum, N.Y.C., 1981 (text by M. Tucker and R. Pincus-Witten, interview by N. Drew, extensive bibliog.); *John Baldessari*, catalogue of exhibition organized by the Stedelijk Van Abbemuseum, Eindhoven, 1981 (text by J. Baldessari, interview by R. Fuchs); C. Owens, "Telling Stories," *Art in America* 69 (May 1981): 129-35.

Larry Bell

Born in Chicago, Illinois, 1939
Lives in Taos, New Mexico

Selected One-Person Exhibitions:
Ferus Gallery, L.A., 1962-63, 65; Pace Gallery, N.Y.C., 1965, 67, 70-73; Stedelijk Museum, Amsterdam, 1967; Galerie Sonnabend, Paris, 1967; Mizuno Gallery, L.A., 1969, 71; Galerie Rudolf Zwirner, Cologne, 1970; Ace Gallery, L.A., 1970-71; Pasadena Art Museum, 1972; Felicity Samuel Gallery, London, 1972; Oakland Museum, 1973; Bonython Gallery, Sydney, 1973; Marlborough Galleria d'Arte, Rome, 1974; Tally Richards Gallery of Contemporary Art, Taos, 1975, 78-81; Fort Worth Art Museum, 1975; Washington University, St. Louis, 1976; Santa Barbara Museum of Art, 1976; Art Museum of South Texas, Corpus Christi, 1976; Hayden Gallery, Massachusetts Institute of Technology, Cambridge, 1977; Roswell Museum and Art Center, N.M., 1978; Multiples Gallery, N.Y.C., 1978-79; Sebastian Moore Gallery, Denver, 1979-80; Hill's Gallery of Contemporary Art, Santa Fe, 1979-80; Marian Goodman Gallery, N.Y.C., 1979, 81-82; L.A. Louver Gallery, Venice, Ca., 1981; Hudson River Museum, Yonkers, 1981; Trisolini Gallery, Ohio University, Athens, 1981; Newport Harbor Art Museum, Newport Beach, Ca., 1982; Ruth S. Schaffner Gallery, Santa Barbara, 1982.

Selected Group Exhibitions:
Museum of Modern Art, N.Y.C., "The Responsive Eye," 1965, "The 1960's," 1967, "Spaces," 1969, "Contemporary Sculpture: Selections from the Collection of MOMA," 1979; Jewish Museum, N.Y.C., "Primary Structures," 1966; La Jolla Museum of Art, "New Modes in California Painting and Sculpture," 1966; Whitney Museum of American Art, N.Y.C., "1966 Annual Exhibition " and "Illuminations and Reflections," 1974, "Two Hundred Years of American Sculpture," 1976; Los Angeles County Museum of Art, "American Sculpture of the Sixties," 1967, and "Art in Los Angeles: Seventeen Artists in the Sixties," 1981; Walker Art Center, Minneapolis, "6 Artists: 6 Exhibitions," 1968, "14 Sculptors: The Industrial Edge," 1969, "Works for New Spaces," 1971; Kassel, "Documenta 4," 1968; Pasadena Art Museum, "Serial Imagery," 1968, and "West Coast: '49-'69," 1969; Stedelijk Van Abbemuseum, Eindhoven, "West Coast USA," 1969; Art Institute of Chicago, "69th American Exhibition," 1970; Tate Gallery, London, "Larry Bell, Robert Irwin, Doug Wheeler," 1970; Joslyn Art Museum, Omaha, "Looking West," 1970; UCLA Art Galleries, L.A., "Transparency, Reflection, Light, Space: 4 Artists," 1971, and "20th Century Sculpture from Southern California Collections," 1972; Hayward Gallery, London, "11 Los Angeles Artists," 1971, and "The Condition of Sculpture," 1975; Long Beach Museum of Art, "Reflections," 1971; Kunstverein, Hamburg, "USA West Coast," 1972; Detroit Institute of Arts, "Art in Space: Some Turning Points," 1973; Galerie Sonnabend, Paris, "Project Pour 'La Defense,'" 1974; National Collection of Fine Arts, Smithsonian Institution, Washington, D.C., "Sculpture: American Directions 1945-1975," 1975; Art Galleries, University of California, Long Beach, "A View Through," 1975; San Francisco Museum of Modern Art, "Painting and Sculpture in California: The Modern Era," 1976; Newport Harbor Art Museum, Newport Beach, Ca., "The Last Time I Saw Ferus, 1957-1976"; Museum of Fine Arts, Santa Fe, "Contemporary Sculpture in New Mexico," 1976; "37th Venice Biennale," 1976; Fort Worth Art Museum, "Solar Fountain Drawings: Larry Bell and Eric Orr," 1977; Art Gallery, California State University, Fullerton, "California Perceptions, Light and Space: Selections from the Wortz Collection," 1979, and "California Innovations," 1981; Albuquerque Museum, "Reflections of Realism," 1979, and "Here and Now: 35 Artists in New Mexico," 1980; Marian Goodman Gallery, N.Y.C., "Further Furniture," 1980; Laguna Beach Museum of Art, Ca., "Southern California Artists: 1940-1980," 1981; Fine Arts Gallery, California State University, Northridge, "Abstraction in Los Angeles 1950-1980," 1981; Crown Point Gallery, Oakland, "Artists' Photography," 1982; Sonoma State University Art Gallery, Rohnert Park, Ca., "Sculpture '82," 1982.

Selected Bibliography:
"Interview: Larry Bell and Eric Orr," *Ocular Magazine* 3 (Spring 1978): 36-43; J. Butterfield, "Larry Bell: Transparent Motif," *Art in America* 66 (Sept./Oct. 1978): 95-9; *Larry Bell: New Work*, catalogue of exhibition organized by the Hudson River Museum, Yonkers, 1981 (text by M. Wortz and L. Bell, extensive bibliog.).

Lynda Benglis

Born in Lake Charles, Louisiana, 1941
Lives in New York City

The forms that I now am doing exist in a broad, symbolic reference to organic imagery in nature's proprioceptive responses and to body gestures. We have reached such a stage of mannerism that even the simplest gesture becomes questionable. By so isolating the gesture and calling attention to the moment, the argument for all other possibilities comes into play. I am interested in this tension of the moment, this frozen gesture.

Selected One-Person Exhibitions:
Paula Cooper Gallery, N.Y.C., 1970-71, 74-76, 78, 81; Galerie Hans Muller, Cologne, 1970; Hayden Gallery, Massachusetts Institute of Technology, Cambridge, 1971; Hansen-Fuller Gallery, S.F., 1972-74, 77, 79; Clocktower, Institute for Art and Urban Resources, N.Y.C., 1973; Portland Center for the Visual Arts, Or., 1973, 80; Texas Gallery, Houston, 1974-75, 79-81; Fine Arts Center Gallery, State University of New York, Oneonta, 1975; Kitchen, N.Y.C., 1975; Margo Leavin Gallery, L.A., 1977, 80, 82; Galerie Albert Baronian, Brussels, 1979-80; Dart Gallery, Chicago, 1979, 81; Georgia State University Art Gallery, Atlanta, 1979; Chatham College, Pittsburgh, 1980; University of South Florida, Tampa, 1980; University of Arizona Museum of Art, Tucson, 1981.

Selected Group Exhibitions:
Detroit Institute of Arts, "Other Ideas," 1969, and "12 Statements Beyond the 60's," 1972; Whitney Museum of American Art, N.Y.C., "1969 Annual Exhibition," "Biennial Exhibition," 1973, 81, "Painting in Relief" (Downtown), 1980, "Developments in Recent Sculpture: Lynda Benglis, Scott Burton, Donna Dennis, John Duff, Alan Saret," 1981; Milwaukee Art Center, "Directions 3: 8 Artists," 1971; Walker Art Center, Minneapolis, "Works for New Spaces," 1971, and "Painting: New Options," 1972; Indianapolis Museum of Art, "Painting and Sculpture Today," 1972; Art Institute of Chicago, Society for Contemporary Art, "32nd Annual Exhibition," 1972; Yale University Art Gallery, New Haven, "Options and Alternatives: Some Directions in Recent Art," 1973; New York Cultural Center, "Choice Dealers/Dealers' Choice," 1974, and "New Editions 74/75," 1975; Baltimore Museum of Art, "Fourteen Artists," 1975; Institute of Contemporary Art of the University of Pennsylvania, Philadelphia, "Video Art," 1975, and "ICA Street Sights 2," 1981; Aarhus Kunstmuseum, Denmark, "The Liberation: Fourteen American Artists," 1976; Museum of Modern Art, N.Y.C., "Recent Acquisitions," 1976; Art Gallery of New South Wales, Sydney, "Biennale of Sydney," 1976; Museum of Contemporary Art, Chicago, "A View of a Decade," 1977, and "3 Dimensional Painting," 1980; Brooklyn Museum Art School, "Contemporary Women: Consciousness and Content," 1977; Solomon R. Guggenheim Museum, N.Y.C., "Recent Acquisitions," 1977; New Jersey State Museum, Trenton, "For the Mind and Eye: Artwork by Nine Americans," 1977; Stedelijk Museum, Amsterdam, "Made by Sculptors," 1978; Albright-Knox Art Gallery, Buffalo, "With Paper, About Paper," 1980; Contemporary Arts Museum, Houston, "Extensions: Jennifer Bartlett, Lynda Benglis, Robert Longo, Judy Pfaff," 1980; San Diego Museum of Art, "Sculpture in California 1975-1980," 1980; "39th Venice Biennale," 1980; Aldrich Museum of Contemporary Art, Ridgefield, Ct., "New Dimensions in Drawing," 1981; Los Angeles Institute of Contemporary Art, "Wallpaper/Roompaper," 1981; 121 Gallery, Antwerp, "American Reliefs," 1981; Sculpture Center, N.Y.C., "Decorative Sculpture," 1981; ELAC, Centres d'Echanges Perrache, Lyon, "Energie New York," 1982; Zabriskie Gallery, N.Y.C., "Flat and Figurative/20th Century Wall Sculpture," 1982; New Museum, N.Y.C., "Early Work," 1982.

Selected Bibliography:
R. Pincus-Witten, "Lynda Benglis: The Frozen Gesture," *Artforum* 13 (Nov. 1974): 54-9; F. Morin, "Lynda Benglis in Conversation with France Morin," *Parachute* 6 (Spring 1977): 9-11; E. Lubbell, "Lynda Benglis," *Arts Magazine* 53 (Jan. 1979): 14; "Lynda Benglis: Interview," *Ocular* 4 (Summer 1979): 30-43; W. Saunders, "Hot Metal," *Art in America* 68 (Summer 1980): 86ff; *Developments in Recent Sculpture: Lynda Benglis, Scott Burton, Donna Dennis, John Duff, Alan Saret*, catalogue of exhibition organized by the Whitney Museum of American Art, N.Y.C., 1981 (text by R. Marshall);

Early Work, catalogue of exhibition organized by the New Museum, N.Y.C., 1982 (intro. by M. Tucker, interview with L. Benglis by L. Gumpert).

Dara Birnbaum

Born in New York City, 1946
Lives in New York City

PM Magazine reproduces an "inverted" television production-set of the 1980s. It frames for the viewer the *mechanical* semblance of a video "matte effect," which currently is produced by the electronics of the television industry within a microsecond of time. The dominant "message-giver" of our time, television delivers its content with such rapidity and in such abundance as to negate decipherment. The "matte effect" is frequently used in video and TV to mask out specific bits and pieces of information from the overall picture and composite program. The video installation *PM Magazine,* reconstructing the "matte" and using excerpts from the nationally televised broadcast of the same name, isolates and arrests specific moments of TV-viewing for closer examination. From within a suspended rendering of the newly indelible image of a girl at a home computer emanates the continuous flow of *PM's* post-war imagery signifying the American Dream— couples dancing and strolling, an ice skater, baton twirler, cheerleader, and the recurring image of a girl licking an ice cream cone. Through the use of highly edited and computerized visuals and sound, a split-second in time representing each of the stereotypical characters' existence is captured and played with. The viewer is left to decide how different these moments really are or whether the electronic processes, which so instantaneously feed information, simply mask the essential questions.

Selected One-Person Exhibitions and Screenings:
Artists Space, N.Y.C., 1977; Kitchen, N.Y.C., 1978, 80; Franklin Furnace, N.Y.C., 1978; Center for Art Tapes, Halifax, 1978, 80; P.S.1, Institute for Art and Urban Resources, Long Island City, 1979; University of California, San Diego, 1979; A Space, Toronto, 1980; Collective for Living Cinema, N.Y.C., 1980; Ritz, N.Y.C., 1980; Real Art Ways, Hartford, 1980; London Video Arts/AIR Gallery, 1980; Hallwalls, Buffalo, 1981; Soho Record Gallery, N.Y.C., 1981; University Art Museum, Berkeley, 1981; Finkelstein Library, Rockland Co., N.Y., 1981; Museum of Modern Art, N.Y.C., 1981; Anthology Film Archives, N.Y.C., 1981; Boston Film and Video Foundation, 1981; Long Beach Museum of Art, 1982; University of California, L.A., 1982; Hudson River Museum, Yonkers, 1982.

Selected Group Exhibitions:
597 Broadway, N.Y.C., "Continuing Works in Various Media," 1975; Anthology Film Archives, N.Y.C., "Video: Curator's Choice (Selections)," 1976, and "T.V. Tactics," 1981; Franklin Furnace, N.Y.C., "Notebooks, Workbooks, Scripts, Scores," 1977, and "T.V. Etc.," 1981; Kitchen, N.Y.C., "Filmworks 78-79" and "Re-Runs," 1979; Mudd Club, N.Y.C., "Small Pieces," 1979, "Cold War

Zeitgeist" and "Mudd Video," 1980, "Mudd Video III," "Mudd Video IV," and "Merle's Rock Video Party," 1981; Galeries Nationales du Grand Palais, Paris, 1980; Clocktower, Institute for Art and Urban Resources, N.Y.C., "Film as Installation," 1980; Städtische Galerie im Lenbachhaus, Munich, "New York Video," 1980; Hallwalls, Buffalo, "Video Installation Show," 1980; American Center, Paris, "Tapes from The Kitchen," "Tapes from MoMA, New York," and "The Kitchen: Video Tapes on Tour," 1980; New Museum, N.Y.C., "Deconstruction/Reconstruction," 1980; N.Y.C., "The Times Square Show," 1980; Espace Lyonnais d'Art Contemporain, Lyon, 1980; Ripartizione Cultura e Spettacolo, Milan, "Camera Incantate—Espansione dell'Immagine," 1980; A Space, Toronto, "Television by Artists," 1980; Grand Central Station, N.Y.C., "Project Grand Central," 1980; Art Museum, Princeton University, "Television/Video," 1980; Los Angeles Independent Film Oasis, 1980; Institute of Contemporary Arts, London, 1980; Kunsthaus Zurich, "New York Video," 1980; Moderna Museet, Stockholm, 1980; Amerika Haus, Berlin, 1980; Stedelijk Van Abbemuseum, Eindhoven, 1980; Art Gallery, University of Banff, 1980; Group Material, N.Y.C., "Gender," 1981; Global Village, N.Y.C., "Select Mudd," 1981, and "New Narrative," 1982; Palazzo Bianco, Genoa, "Il Gergo Inquieto," 1981; American Film Institute, Washington, D.C., "National Video Festival," 1981; La Mamelle, Inc., S.F., 1981; Bâtiment de L'Ancien Seminaire Derrière Les Ramparts, Fribourg, Switz., 1981; Kijkhuis Gallery, The Hague, 1981; Institute of Contemporary Art, Virginia Museum of Fine Arts, Richmond, 1981; "San Francisco International Video Festival," 1981; Bologna, "Women's Video Festival," 1982; University Art Museum, Berkeley, "New Directions in Music and Video," 1982; Renaissance Society at the University of Chicago, "Art and the Media," 1982; Kassel, "Documenta 7," 1982.

Selected Bibliography:
Deconstruction/Reconstruction: The Transformation of Photographic Information into Metaphor, catalogue of exhibition organized by the New Museum, N.Y.C., 1980 (text by S. Rice); R. Brooks, "TV Transformations: an examination of the video tapes of New York artist Dara Birnbaum," *ZG,* no. 1 (1981): n.p.; "Dara Birnbaum Talks to John Sanborn," *ZG,* no. 3 (1981): n.p.; D. Birnbaum, *Rough Edits/Popular Image Video—Dara Birnbaum,* Halifax: Press of the Nova Scotia College of Art and Design, 1982.

Mel Bochner

Born in Pittsburgh, Pennsylvania, 1940
Lives in New York City

Selected One-Person Exhibitions:
Visual Arts Gallery, School of Visual Art, N.Y.C., 1966; Galerie Heiner Friedrich, Munich, 1969; Galerie Konrad Fischer, Dusseldorf, 1969; Ace Gallery, L.A., 1969; Galleria Sperone, Turin, 1970; Galleria Toselli, Milan, 1970, 72; 112 Greene Street, N.Y.C., 1971; Museum of Modern Art, N.Y.C., 1971; Galerie Sonnabend, Paris, 1972-74, 78;

Sonnabend Gallery, N.Y.C., 1972-73, 75-76, 78, 80, 82; Lisson Gallery, London, 1972; Galerie MTL, Brussels, 1972; Galleria Marilena Bonomo, Bari, 1972; Galleria Schema, Florence, 1974, 78; University Art Museum, Berkeley, 1974; Galerie Ricke, Cologne, 1975; Baltimore Museum of Art, 1976; Bernier Gallery, Athens, 1977; Daniel Weinberg Gallery, S.F., 1978, 81; Galerie Art in Progress, Düsseldorf, 1979; Texas Gallery, Houston, 1981; University Gallery, Meadows School of the Arts, Southern Methodist University, Dallas, 1981.

Selected Group Exhibitions:
Finch College Museum of Art, N.Y.C., "Art in Series," 1967, and "Art in Process IV," 1969; American Federation of Arts, N.Y.C., "Rejective Art," 1968; Museum of Contemporary Art, Chicago, "Art by Telephone," 1969, and "A View of a Decade," 1977; Kunsthalle Bern, "When Attitudes Become Form" and "Plans and Projects as Art," 1969; Städtisches Museum, Leverkusen, "Konzeption/Conception," 1969, and "Zeichnungen 3: American Drawings," 1975; Seattle Art Museum, "577,087," 1969, and "American Art, Third Quarter Century," 1973; Museum of Modern Art, N.Y.C., "Information," 1970, "Print Sequence," 1975, "Drawing Now," 1976; Moore College of Art, Philadelphia, "Recorded Activities," 1970; Museo Civico d'Arte Moderna, Turin, "Conceptual Art/Arte Povera/Land Art," 1970; New York Cultural Center, N.Y.C., "Conceptual Art and Conceptual Aspects," 1970, and "3D into 2D: Drawing for Sculpture," 1973; Jewish Museum, N.Y.C., "Using Walls," 1970; Allen Memorial Art Museum, Oberlin College, "Art in the Mind," 1970; Galerie Nachst St. Stephen, Innsbruck, "Situation Concepts," 1971; Kassel, "Documenta 5," 1972; Kunstmuseum Basel, "Konzept-Kunst," 1972; Fogg Art Museum, Harvard University, Cambridge, "New American Graphic Art," 1973; Whitney Museum of American Art, N.Y.C., "American Drawings," 1973, "Biennial Exhibition," 1977, 79, "The Decade in Review," 1979; Parcheggio di Villa Borghese, Rome, "Contemporanea," 1973; Art Museum, Princeton University, "Line As Language: Six Artists Draw," 1974; Art Institute of Chicago, "Idea and Image in Recent Art" 1974, and "72nd American Exhibition," 1976; Cologne, "Project '74," 1974; Contemporary Arts Center, Cincinnati, "Bochner, Le Va, Rockburne, Tuttle," 1975; High Museum of Art, Atlanta, "The New Image," 1975; Baltimore Museum of Art, "14 Artists," 1975; Art Gallery of Ontario, Toronto, "Prints," 1975; Fort Worth Art Museum, "Fourteen Artists: The New Decade," 1976; Philadelphia Museum of Art, "Eight Artists," 1978; University Art Galleries, University of California, Santa Barbara, "Contemporary Drawing/New York," 1978; Tampa Bay Art Center, "Three Installations: Acconci, Bochner, Le Va," 1978; Aldrich Museum of Contemporary Art, Ridgefield, Ct., "The Minimal Tradition," 1979; Palazzo Reale, Milan, "Pintura Ambiente," 1979; Musée National d'Art Moderne, Centre Georges Pompidou, Paris, "Oeuvres Contemporaines des Collections Nationales," 1979, and "Murs," 1981; Hayden Gallery, Massachusetts Institute of Technology,

Cambridge, "Mel Bochner/Richard Serra," 1980.

Selected Bibliography:
Mel Bochner: Number and Shape, catalogue of exhibition organized by the Baltimore Museum of Art, 1976 (text by B. Richardson); J. Perrone, "Mel Bochner: Getting from A to B," *Artforum* 16 (Jan. 1978): 24-32; *Mel Bochner/Richard Serra,* catalogue of exhibition organized by the Hayden Gallery, Massachusetts Institute of Technology, Cambridge, 1980 (intro. by K. Halbreich); *Mel Bochner: Twenty-Five Drawings,* catalogue of exhibition organized by the University Gallery, Meadows School of the Arts, Southern Methodist University, Dallas, 1981.

Richard Bosman

Born in Madras, India, 1944
Lives in New York City

The first figurative images that I made were linocuts drawn from a book of Egyptian hieroglyphics. I continue to use the human figure as a symbol but not exclusively. Social, political and cultural concerns become involved when the figure is placed in a context or a physical setting.

Some of my images are derived from Chinese comic books, others are entirely made up. All of them have a primitiveness that I believe makes them more real; that is, the process of painting is visible.

Film and literature are loaded with modern themes such as violence and sex. Why should these subjects be barred from painting? If a painting is to be more than decoration, it must reflect these prevalent preoccupations. Watching Kojak re-runs on T.V. and reading detective stories by Dashiel Hammett and Mickey Spillane make me want to paint similar images.

Someone once said, "There is no room in American life between the Coke bottle and the T.V. set for existentialism." I think of that when I make a painting, something that's been done for centuries. The historical connection is both exhilarating and paralyzing. I want my paintings to have the same effect as a crowded dream that is fascinating and terrifying at the same time.

Selected One-Person Exhibitions:
Brooke Alexander, Inc., N.Y.C., 1980-81; Fort Worth Art Museum, 1982; Thomas Segal Gallery, Boston, 1982; Dart Gallery, Chicago, 1982.

Selected Group Exhibitions:
Gallery of the New York Studio School, 1971-72; Mary Kay Loft Gallery, N.Y.C., 1973; Mary Paz Gallery, Malaga, 1975; Committee for the Visual Arts, N.Y.C., 1977; Hundred Acres Gallery, N.Y.C., 1977; Brooke Alexander, Inc., N.Y.C., "Illustration & Allegory," 1980, "Paintings by Richard Bosman, Ken Goodman, Dennis Kardon and Richard Mock" and "Represent, Representation, Representative," 1981; Drawing Center, N.Y.C., "Selections," 1980, and "New Drawing in America," 1982; Nigel Greenwood, Ltd., London, "REALLIFE Magazine Presents," 1981; Goddard-Riverside Community Center, N.Y., "Menagerie," 1981; Hayden Gallery, Massachusetts Institute of Technology, Cambridge, "Figurative Aspects of Recent Art," 1981; Museum of Modern Art (Penthouse), N.Y.C., "Summer Light," 1981; Pratt Manhattan Center, N.Y.C., "For Love and Money: Dealer's Choice," 1981; Fort Lauderdale Museum of the Arts, "The Commodities Corporation Collection Exhibition," 1982; Young-Hoffman Gallery, Chicago, "Group Show," 1982; Hamilton Gallery, N.Y.C., "The Abstract Image," 1982.

Selected Bibliography:
Illustration & Allegory, catalogue of exhibition organized by Brooke Alexander, Inc., N.Y.C., 1980 (text by C. Ratcliff); T. Lawson, "Richard Bosman," *Artforum* 19 (Jan. 1981): 75; D. Phillips, "Richard Bosman," *Arts Magazine* 55 (Jan. 1981): 13; A. Parks, "Richard Bosman," *Arts Magazine* 56 (Sept. 1981): 11.

Joan Brown

Born in San Francisco, California, 1938
Lives in San Francisco, California

Selected One-Person Exhibitions:
6 Gallery, S.F., 1957; Spatsa Gallery, S.F., 1959; Batman Gallery, S.F., 1959; Staempfli Gallery, N.Y.C., 1960-61, 64; David Stuart Gallery, L.A., 1961-62, 64; Hansen-Fuller Gallery, S.F., 1968, 70, 76; Sacramento State College Art Gallery, 1970; San Francisco Museum of Modern Art, 1971; San Francisco Art Institute, 1973; Charles Campbell Gallery, S.F., 1974-75; University Art Museum, Berkeley, 1974; Allan Frumkin Gallery, N.Y.C., 1974, 76, 79, 82; Allan Frumkin Gallery, Chicago, 1975, 77; Re: Vision Gallery, Santa Monica, 1976; Clarke-Benton Gallery, Santa Fe, 1977; R.L. Nelson Gallery, University of California, Davis, 1977; Wadsworth Atheneum, Hartford, 1977; University of Akron, 1978; San Jose Museum of Art, 1979; Koplin Gallery, L.A., 1982.

Selected Group Exhibitions:
Richmond Art Center, Ca., "Annual Exhibition," 1957, 59-60; San Francisco Museum of Modern Art, "Annual Painting and Sculpture Exhibition of the San Francisco Art Association," 1957-58, 63, "San Francisco Art Institute Centennial Exhibition," 1971, "Painting and Sculpture in California: The Modern Era," 1976; Whitney Museum of American Art, N.Y.C., "Young America 1960," "1972 Annual Exhibition," "1977 Biennial Exhibition," "Cartoons" (Downtown), 1978; Art Institute of Chicago, "64th American Exhibition," 1961; Krannert Art Museum, University of Illinois, Champaign, "Contemporary American Painting and Sculpture," 1961, 63, 73-74; California Palace of the Legion of Honor, S.F., "The Nude," 1962; M.H. de Young Memorial Museum, S.F., "Phelan Award Exhibition," 1963; Stanford University Museum and Art Gallery, "Current Painting and Sculpture in the Bay Area," 1964; University Art Museum, Berkeley, "Funk," 1967; San Francisco Art Institute, "Annual Invitational Drawing Show," 1968; Oakland Museum, "Exhibition of Studio Drawings," 1973, and "Bay Area Artists Exhibition," 1975; Mt. Holyoke College, So. Hadley, Ma., "Art as a Muscular Principle," 1975; JPL Fine Arts Gallery, London, "California Gold," 1975; James Wallis Gallery, S.F., "Retrospective of Sculpture in the Bay Area," 1976; Joe & Emily Lowe Art Gallery, Syracuse University, "Critic's Choice," 1977; Tortue Gallery, Santa Monica, "California Figurative Painters," 1977; The Hague, "Recent Art from San Francisco," 1977; New Museum, N.Y.C., "Bad Painting Show," 1978; New Gallery of Contemporary Art, Cleveland, "West Coast Artists," 1978; Cincinnati Art Museum, "Collector's Choice," 1978; Weatherspoon Art Gallery, University of North Carolina, Greensboro, "Art on Paper," 1978; American Foundation for the Arts, Miami, "Story Telling Art," 1979; Chrysler Museum, Norfolk, "American Figure Painting, 1950-1980," 1980; Newport Harbor Art Museum, Newport Beach, Ca., "Inside Out: The Self Beyond Likeness," 1981; Rutgers University Art Gallery, New Brunswick, "Realism and Realities: The Other Side of American Painting 1940-1960," 1982; New Museum, N.Y.C., "Early Work," 1982.

Selected Bibliography:
Joan Brown, catalogue of exhibition organized by the University of Akron, 1978 (text by D. Goldeen); J. Perone, "Joan Brown, Allan Frumkin Gallery," *Artforum* 17 (Summer 1979): 71-2; N. Menzies, "Joan Brown: Still Enigmatic and Dazzling," *Artweek* 13 (Mar. 6, 1982): 1; *Early Work,* catalogue of exhibition organized by the New Museum, N.Y.C., 1982 (intro. by M. Tucker, interview with J. Brown by L. Gumpert).

Scott Burton

Born in Greensboro, Alabama, 1939
Lives in New York City

My objects are intended to be both sculpture and furniture. In a gallery or museum, the latter category is often unperceived by the viewer, but still these are *really* chairs and tables.

Selected One-Person Exhibitions:
Artists Space, N.Y.C., 1975; Droll/Kolbert Gallery, N.Y.C., 1977; Brooks Jackson Iolas Gallery, N.Y.C., 1978; Protetch-McIntosh Gallery, Washington, D.C., 1979; Daniel Weinberg Gallery, S.F., 1980; Dag Hammarskjold Plaza Sculpture Garden, N.Y.C., 1981; Max Protetch Gallery, N.Y.C., 1981.

Selected Group Exhibitions:
Whitney Museum of American Art, N.Y.C., "Biennial Exhibition," 1975, 81, and "Developments in Recent Sculpture: Lynda Benglis, Scott Burton, Donna Dennis, John Duff, Alan Saret," 1981; Akademie der Künste, Berlin, "New York-Downtown Manhattan: Soho," 1976; P.S.1, Institute for Art and Urban Resources, Long Island City, "Rooms P.S.1," 1976; Institute of Contemporary Art of the University of Pennsylvania, Philadelphia, "Improbable Furniture," 1977, and "Material Pleasures," 1980; Museum of the American Foundation for the Arts, Miami, "Patterning and Decoration," 1977; Museum of Contemporary Art, Chicago, "A View of a Decade," 1977; Solomon R. Guggenheim Museum, N.Y.C., "Young American Artists: 1978 Exxon National Exhibition"; Detroit Institute of Arts, "Image and Object in Contemporary Sculpture," 1979; Neuberger Museum, State University of New York, Purchase, "Ten Artists/Artists Space,"

1979; Marian Goodman Gallery, N.Y.C.,
"Further Furniture," 1980; Grey Art
Gallery and Study Center, New York University, "Perceiving Modern Sculpture:
Selections for the Sighted and Non-
Sighted," 1980; Indianapolis Museum of
Art, "Painting and Sculpture Today,"
1980; Otis Art Institute of Parsons School
of Design, L.A., "Furnishings by Artists,"
1980; Art Gallery, Myers Fine Arts
Building, State University of New York,
Plattsburgh, "Usable Art," 1981; Wave
Hill Environmental Center and Sculpture
Gardens, Bronx, "Tableaux," 1981;
Kassel, "Documenta 7," 1982.

Selected Bibliography:
R. Pincus-Witten, "Scott Burton: Conceptual Performance as Sculpture," *Arts
Magazine* 51 (Sept. 1976): 112-17; J.
Howell, "Acting/Non-Acting: Interview
with Scott Burton," *Performance Art
Magazine,* no. 2 (1978): 7-10; R. Pincus-
Witten, "Camp Meetin': The Furniture
Pieces of Scott Burton," *Arts Magazine* 53
(Sept. 1978): 103-5; R. Smith, "Scott Burton Designs on Minimalism," *Art in
America* 66 (Nov./Dec. 1978): 138-40; M.
Auping, "Scott Burton: Individual Behavior Tableaux," *Images and Issues* 1
(Summer 1980): 46-7; John Romine,
"Scott Burton: Interview," *Upstart* 5
(May 1981): 6-9; *Developments in Recent
Sculpture: Lynda Benglis, Scott Burton,
Donna Dennis, John Duff, Alan Saret,*
catalogue of exhibition organized by the
Whitney Museum of American Art,
N.Y.C., 1981 (text by R. Marshall).

Peter Dean

Born in Berlin, Montana, 1939
Lives in New York City

I'm a magician through whom the images
of our time pass and become paintings.

I'm an interpreter of reality into fantasy
and back again.

I'm a juggler of textures and color.

I'm a seer of the past and a prophet of
the future.

I ride the hurricane.

I walk the tight rope of sanity.

I live on the edge of the world.

Selected One-Person Exhibitions:
Aspects Gallery, N.Y.C., 1963-64;
Waynesburg College, Pa., 1967; Elizabeth
Street Gallery, N.Y.C., 1967-69; E.F.
Hutton Art Center, C.W. Post College,
Brookville, N.Y., 1970; Paul Kessler Gallery, Provincetown, 1970; J.M. Kohler
Arts Center, Sheboygan, 1970; Bienville
Gallery, New Orleans, 1970, 73, 75, 77,
79, 81; Allan Stone Gallery, N.Y.C., 1970,
73, 78, 80; New Orleans Museum of Art,
1972; Union Gallery, Louisiana State University, Baton Rouge, 1974; Heath Gallery, Atlanta, 1975; Rabinovitch and
Guerra Gallery, N.Y.C., 1976; Alexander
Monett Gallery, Brussels, 1976, 78; Aaron
Berman Gallery, N.Y.C., 1977; Daedal
Gallery, Baltimore, 1978; Huber Gallery,
Washington, D.C., 1978; Madison Art
Center, Wi., 1978; Galerie Noire, Paris,
1979; Picker Art Gallery, Colgate
University, Hamilton, 1981; University
Art Gallery, University of North Dakota,
Grand Forks, 1981; Galerie Darthea
Speyer, Paris, 1981; Semaphore Gallery,
N.Y.C., 1982.

Selected Group Exhibitions:
East Hampton Gallery, N.Y., "The Visionaries," 1967; Spring Street Museum,
N.Y.C., 1967; Loeb Student Center, New
York University, "Angry Arts," 1967;
"Bienal Internacional Del Deporte en las
Bellas Artes," Madrid, 1969, and
Barcelona, 1971; Allan Stone Gallery,
N.Y.C., "Grotesque, Fetishes, Fantasy"
and "New Talent," 1969; New School for
Social Research, N.Y.C., "Rhino Horn,"
1970; Sonraed Gallery, N.Y.C., 1970;
Dayton Art Center, 1971; Corcoran Gallery of Art, Washington, D.C., "32nd
Biennial of American Painting," 1971;
University of Hartford, 1971; Gallery
Marc, Washington, D.C., 1971; Academy
Museum, National Institute of Arts and
Letters, N.Y.C., 1973; Herbert Benlevy
Gallery, N.Y.C., 1973; Ankrum Gallery,
L.A., 1974; Allan Frumkin Gallery,
N.Y.C., "Portraits, 1970-1975," 1975;
L'Atelier du Grand Hornu, Mons, "USA
Contemporary Artists," 1976; Hathorn
Gallery, Skidmore College, Saratoga
Springs, "Drawings," 1976, and
"American Landscapes," 1978; Galerie
Roger d'Amacourt, Paris, "American
Drawings," 1978; Fischbach Gallery,
N.Y.C., 1980; Osuna Gallery, Washington, D.C., "Contemporary Landscapes,"
1980; Chrysler Museum, Norfolk,
"Crimes of Compassion," 1981.

Selected Bibliography:
D. Anderson, "Peter Dean," *Arts Magazine* 51 (Apr. 1977): 21; P. Fingesten,
"Peter Dean," *Arts Magazine* 52 (May
1978): 78; J. Deckert, "Peter Dean," *Arts
Magazine* 55 (Oct. 1980): 13; *Peter Dean:
Landscapes of the Mind,* catalogue of
exhibition organized by the Picker Art
Gallery, Colgate University, Hamilton,
1981 (text by D.E. Stetson).

Rafael Ferrer

Born in San Juan, Puerto Rico, 1933
Lives in Philadelphia, Pennsylvania

Selected One-Person Exhibitions:
University of Puerto Rico, Mayaguez,
1964; Pan American Union, Washington,
D.C., 1966; Leo Castelli Gallery, N.Y.C.,
1969-70; Eastern Connecticut State College, Willimantic, 1969; Galerie M.E.
Thelen, Cologne, 1969-70; Philadelphia
Museum of Art, 1970; University of Hartford Art Gallery, 1970; Galerie Michery,
Amsterdam, 1970; Institute of Contemporary Art of the University of Pennsylvania, Philadelphia, 1971; University of
Rhode Island Fine Arts Center, Kingston,
1971; Whitney Museum of American Art,
N.Y.C., 1971; Museum of Contemporary
Art, Chicago, 1972; Contemporary Arts
Center, Cincinnati, 1973; Miami-Dade
Community College Art Gallery, 1973;
Phyllis Kind Gallery, Chicago, 1974;
Museum of Modern Art, N.Y.C., 1974;
Nancy Hoffman Gallery, N.Y.C., 1974-75,
77-78, 82; Phoenix Gallery, S.F., 1974;
Delaware Art Museum, Wilmington,
1974; Instituto de Cultura Puertoriqueña,
San Juan, 1975; New Gallery of Contemporary Art, Cleveland, 1976, 78; Central
Michigan University, Mt. Pleasant, 1976;
Fort Worth Art Museum, 1977; Galerie
Darthea Speyer, Paris, 1977; Marianne
Deson Gallery, Chicago, 1977; Albright-
Knox Art Gallery, Buffalo, 1977; Institute
of Contemporary Art, Boston, 1978;
Frumkin/Struve Gallery, Chicago, 1980;

Hamilton Gallery of Contemporary Art,
N.Y.C., 1980; Okun-Thomas Gallery, St.
Louis, 1981; Swen Parson Gallery,
Northern Illinois University, DeKalb,
1982.

Selected Group Exhibitions:
Peale House Galleries, Pennsylvania
Academy of the Fine Arts, Philadelphia,
"Art in Latin America," 1967; Institute of
Contemporary Art of the University of
Pennsylvania, Philadelphia, "Between
Object and Environment," 1968, "Dwellings" and "Masks, Tents, Vessels, Talismans," 1979, "Drawings: The Pluralist
Decade" and "Urban Encounters: Art,
Architecture, Audience," 1980; Museum
of Art, University of Puerto Rico,
Mayaguez, "Outdoor Sculpture," 1968,
and "FRARMRRIREEROFIBSEATERLR
(Robert Morris-Rafael Ferrer)," 1969;
Finch College Museum of Art, N.Y.C.,
"Art in Process IV," 1969; Vancouver Art
Gallery, "955,000," 1969; Seattle Art
Museum, "557,087," 1969; Whitney
Museum of American Art, N.Y.C., "Anti-
Illusion: Procedures/Materials," 1969,
"1970 Sculpture Annual," "1973 Biennial
Exhibition"; Stedelijk Museum, Amsterdam, "Op Losse Schroven," 1969;
Kunsthalle Bern, "When Attitudes
Become Form," 1969; Contemporary Arts
Center, Cincinnati, "Monumental Art,"
1970; Museum of Modern Art, N.Y.C.,
"Information," and "Drawings on Maps"
(Penthouse), 1977; Allen Memorial Art
Museum, Oberlin College, "Art in the
Mind," 1970; Museumverein, Wuppertal,
Germany, "Funf Kunstler," 1970;
Museum of Contemporary Art, Chicago,
"Six Sculptors," 1971, and "A View of a
Decade," 1977; Corcoran Gallery of Art,
Washington, D.C., "Depth and Presence," 1971; Philadelphia Museum of
Art, "The Invisible Artist," 1973, and
"New Acquisitions," 1975; Milwaukee
Art Center, "Alchemy of the Third
Planet," 1974; Virginia Museum of Fine
Arts, Richmond, "Works on Paper,"
1974; Indianapolis Museum of Art,
"Painting and Sculpture Today, 1974";
Moore College of Art, Philadelphia,
"North, East, West, South and Middle,"
1975; Rutgers University Art Gallery,
New Brunswick, "A Response to the Environment," 1975; Vassar College Art
Gallery, Poughkeepsie, "Primitive
Presence in the 70's," 1975; New York
Botanical Garden Museum, "Looking Inside: Latin American Presence in New
York," 1976; Fort Wayne Art Institute,
"Hue and Far Cry of Color," 1976; Xerox
Square Exhibit Center, Rochester, N.Y.,
"Latin Excellence," 1977; Northeastern
University Art Gallery, Boston, "Contemporary Latin American Artists," 1977; Art
Institute of Chicago, Society for Contemporary Art, "35th Annual Exhibition:
Drawings of the 70's," 1977; Contemporary Arts Museum, Houston, "Narrative Arts," 1977; Dayton Art Institute,
"Skin," 1977, and "Paper," 1978; New
Gallery of Contemporary Art, Cleveland,
"Soft Sculpture," 1977; Queens Museum,
"Private Myths," 1978; Worcester Art
Museum, "For Collectors," 1978; Cranbrook Academy of Art, Bloomfield Hills,
Mi., "Viewpoint 77: Options in Painting," 1978; Madison Art Center, Wi.,
"Recent Works on Paper by Contemporary American Artists," 1978; Denver
Art Museum, "Poets and Painters," 1980;
Hudson River Museum, Yonkers, "Super-

show," 1980; "39th Venice Biennale," 1980; Albert A. List Museum, Providence, "Brown University Invitational Exhibition," 1980; Lowe Art Museum, Coral Gables, "Fabrications," 1980.

Selected Bibliography:
Rafael Ferrer: Recent Work and an Installation, catalogue of exhibition organized by the Institute of Contemporary Art, Boston, 1978 (text by R. Ferrer); C. Ratcliff, "Ferrer's Sun and Shade," *Art in America* 68 (Mar. 1980): 80-6; *Ulysses of Puerto Rico: Rafael Ferrer*, catalogue of exhibition organized by the Swen Parson Gallery, Northern Illinois University, DeKalb, 1982 (interview with R. Ferrer by M. Flanagan and J. Kind, text by J. Kind).

Jack Goldstein

Born in Montreal, Canada, 1945
Lives in Brooklyn, New York

Media is sensational.

Light is the gesture of progress; a far-off view of a city at night gives a reading of the pulse of man.

Painting from a photograph produces a clean "negative" of art without expression.

An explosion is a beauty before its consequences.

Art and War use cold reason to immobilize imagination.

A Futuristic vision sees the display in destruction—a burning building is not too different than the 4th of July as celebration.

Spontaneity is a metaphor for risk.

A close-up of what can only be seen from a distance is as close as we can come to a true abstraction.

Sky is to the 20th century what landscape was to the 19th century.

The by-products of culture symbolize our position in the world. The details of living prevent us from seeing symbolically.

Selected One-Person Exhibitions:
California Institute of the Arts, Valencia, 1971; Gladys K. Montgomery Art Center, Pomona College, Ca., 1971; Nigel Greenwood Ltd., London, 1972; Rico Mizuno Gallery, L.A., 1972; Galerie Françoise Lambert, Milan, 1974; Artists Space, N.Y.C., 1976; Centre d'Art Contemporain, Geneva, 1978, 80; Hallwalls, Buffalo, 1978; Foundation for Artists' Resources, L.A., 1979; Groninger Museum, Groningen, 1979; Metro Pictures, N.Y.C., 1980-81; Théatre Le Palace, Paris, 1981; Larry Gagosian Gallery, L.A., 1982.

Selected Group Exhibitions:
Long Beach Museum of Art, "Temple Street Artists," 1970; Los Angeles County Museum of Art, "Twenty-Four Young Los Angeles Artists," 1971; Project, Inc., Boston, "Artists' Performance Series," 1972; Kunstmuseum Basel, "Artists' Films," 1974; School of the Art Institute of Chicago, "Avant-Garde Film: Jack Goldstein, Babette Mangolte and Yvonne Rainer," 1976; State University of New York, Buffalo, "January: Jon Borofsky, Scott Burton, Steve Gianakos and Jack Goldstein," 1976; Artists Space, N.Y.C., "Pictures," 1977, and "A Sound Selection: Audio Works by Artists," 1978; Fort Worth Art Museum, "The Record as Artwork from Futurism to Contemporary Art," 1977; Groninger Museum, Groningen, "16 Dagen," 1978; Thomas/Lewellen Gallery, L.A., "Records, Films and Video: Baldessari, Goldstein, Askevold and Segalove," 1978; Studio d'Arte Cannaviello, Milan, "Recognizable Images," 1979; Kitchen, N.Y.C., "Filmworks," 1979; P.S.1, Institute for Art and Urban Resources, Long Island City, "Sound," 1979; Clocktower, Institute for Art and Urban Resources, N.Y.C., "Film as Installation," 1980; Padiglione d'Arte Contemporanea, Milan, "Horror Pleni: Pictures in New York Today," 1980; Palazzo della Triennale, Milan, "New Image," 1980; Project Art Space, Florence, 1980; Museo di Sant'Agostino, Genoa, "Il Gergo Inquieto: Idola," 1981; Galerie Chantal Crousel, Paris, "Picturealism—New York," 1981; Museen der Stadt Köln, "Heute: Westkunst," 1981; Neuberger Museum, State University of New York, Purchase, "Soundings," 1981; California Institute of the Arts, Valencia, "Exhibition: Tenth Anniversary," 1981; Renaissance Society at the University of Chicago, "Art and the Media," 1982; Kassel, "Documenta 7," 1982.

Selected Bibliography:
M. Fisher, "Talking to Jack Goldstein," *Journal, Los Angeles Institute of Contemporary Art* (Apr.-May 1977): 42-4; *Jack Goldstein*, catalogue of exhibition organized by Hallwalls, Buffalo, 1978 (text by D. Salle); T. Lawson, "Long Distance Information," *REALLIFE Magazine* (Summer 1980): 3-5; R. Brooks, "Life in Space" and M. Newman, "Michael Newman Talks to Jack Goldstein," *ZG*, no. 3 (1981): n.p.; J. Hutton, "Jack Goldstein," *Arts Magazine* 56 (Jan. 1982): 17; C. Owens, "Back to the Studio," *Art in America* 70 (Jan. 1982): 104-5.

Dan Graham

Born in Urbana, Illinois, 1942
Lives in New York City

Pavilion/Sculpture for Argonne is a sculpture-sized model for a larger work designed for an outdoor pavilion. In one sense it relates to the problem of placing "Minimal" sculpture outdoors; in another sense it is clearly architectural.

It has a relation to Rococo structure, such as Cuvilliés' Amalienburg Pavilion, situated in a wooded area 300 yards from Ludwig I's Nymphenburg Palace in Munich. The structurally open framework relates to pavilions of Mies van der Rohe, but mostly to Rietveld's sculpture pavilion at the Kröller-Müller Museum. *Pavilion/Sculpture for Argonne* is an empty monument whose semiotic meaning comes from the fact that it uses the materials (glass, mirrors, and steel) of the modern city environment (specifically, alluding to the commercial glass office structure), but in an arcadian ("utopian") setting. The mirrors, openings, and quasi-reflective glass windows make the work psychologically and socially self-reflective. *Pavilion/Sculpture for Argonne* creates its own social order, one which is based on two sets of social divisions. The first is between two audiences within the pavilion on opposite sides of the diagonal division. The second is between those inside the work and those outside.

Presented inside an interior space, *Pavilion/Sculpture for Argonne* resembles "Minimal" sculpture. Outside, where the lighting continuously changes due to the movement of the overhead sun and altering sky conditions, the work literally reflects its environment. Reflections on its mirror and glass and the shadows from the framework are subject to continual variation from overhead sun and passing clouds. The form is cubist and architectonic—open to entry and use—*and psychological*—reflective of the spectator's body and gaze.

Selected One-Person Exhibitions:
Anna Leonowens Gallery, Nova Scotia College of Art and Design, Halifax, 1970-71; Lisson Gallery, London, 1972, 74, 81; Galleria Toselli, Milan, 1972; Galerie MTL, Brussels, 1973, 75; Galerie Zwirner, Cologne, 1973; Galleria Schema, Florence, 1973; Gallery A-402, California Institute of the Arts, Valencia, 1973; Galleria Marilena Bonomo, Bari, 1974; Galerie 17, Paris, 1974; John Gibson Gallery, N.Y.C., 1975; Palais des Beaux-Arts, Brussels, 1975; International Cultural Centrum, Antwerp, 1975; Samangallery, Genoa, 1976; Galerie Vega, Liège, 1976; Galerie Annemarie Verna, Zurich, 1976; Kunsthalle Basel, 1976; Leeds Polytechnic Gallery, 1977; Stedelijk Van Abbemuseum, Eindhoven, 1977; Museum van Hedendaagse Kunst, Ghent, 1977; Corps de Garde, Groningen, 1978; Museum of Modern Art, Oxford, 1978; Franklin Furnace, N.Y.C., 1979; Galerie Rüdiger Schöttle, Munich, 1979, 80; Center for Art Tapes, Halifax, 1979; Museum of Modern Art, N.Y.C., 1980; Museum of Contemporary Art, Lisbon, 1980; P.S.1, Institute for Art and Urban Resources, Long Island City, 1980; Center for the Arts, Muhlenberg College, Allentown, Pa., 1981; Institute of Contemporary Art of the University of Pennsylvania, Philadelphia, 1981; Renaissance Society at the University of Chicago, 1981.

Selected Group Exhibitions:
Visual Arts Gallery, School of Visual Arts, N.Y.C., "Working Drawings and Other Visible Things on Paper Not Necessarily Meant to be Viewed as Art," 1966, and "Time Photography," 1969; Finch College Museum of Art, N.Y.C., "Project Art," 1966, and "Art in Series," 1967; Fordham University, N.Y.C., "Artist-Writers," 1967; Lannis Museum of Normal Art, N.Y.C., "Fifteen Artists Present their Favorite Book," 1967; Seattle Art Museum, "557,087," 1969; Städtisches Museum, Leverkusen, "Konzeption-Conception," 1969; Vancouver Art Gallery, "955,000," 1970; Allen Memorial Art Museum, Oberlin College, "Art in the Mind," 1970; Museum of Modern Art, N.Y.C., "Information," 1970; Museum of Fine Arts, Boston, "Earth, Air, Fire, Water: Elements of Art," 1971; Museo de Arte Moderno de la Ciudad, Buenos Aires, "Arte de Sistemas," 1971; Kassel, "Documenta," 1972, 82; Kunstverein, Cologne, "Kunst Bleibt Kunst: Projekt '74," 1975; Institute of Contemporary Art of the University of Pennsylvania, Philadelphia, "Video Art," 1975; Royal College of Art, London, "A

Space: A Thousand Words," 1975; "37th Venice Biennale: Ambiente Arte," 1976; Dalhousie Art Gallery, Dalhousie University, Halifax, "In Video," 1977; Gallery of the University of Western Ontario, London, "5 Artists Using Video," 1979; Museum of Contemporary Art, Chicago, "Concept/Narrative/-Document," 1979; Art Institute of Chicago, "73rd American Exhibition," 1979; Musée National d'Art Moderne, Centre Georges Pompidou, Paris, "Oeuvres Contemporaines des Collections Nationales Accrochage III," 1979; Ohio State University Gallery, Columbus, "Artist as Architect/Architect as Artist," 1981.

Selected Bibliography:
D. Graham, For Publication, L.A., Otis Art Institute of Parsons School of Design, 1975; D. Graham, Films, Geneva: Ecart/Salle Patino, 1977; Articles, ed. by R. Fuchs, Eindhoven: Stedelijk Van Abbemuseum, 1978 (text by D. Graham); Dan Graham: Video-Architecture-Television, Halifax and New York: Presses of the Nova Scotia College of Art and Design and New York University, 1979 (extensive bibliog. through 1978); Dan Graham: Buildings and Signs, Chicago and Oxford, Renaissance Society at the University of Chicago and the Modern Art Museum, 1981 (intro. by A. Rorimer, texts by D. Graham, extensive bibliog. 1978 through 1981).

Jenny Holzer

Born in Gallipolis, Ohio, 1950
Lives in New York City

DON'T TALK DOWN TO ME. DON'T BE POLITE TO ME. DON'T TRY TO MAKE ME FEEL NICE. DON'T RELAX. I'LL CUT THE SMILE OFF YOUR FACE. YOU THINK I DON'T KNOW WHAT'S GOING ON. YOU THINK I'M AFRAID TO REACT. THE JOKE'S ON YOU. I'M BIDING MY TIME, LOOKING FOR THE SPOT. YOU THINK NO ONE CAN REACH YOU, NO ONE CAN HAVE WHAT YOU HAVE. I'VE BEEN PLANNING WHILE YOU'RE PLAYING. I'VE BEEN SAVING WHILE YOU'RE SPENDING. THE GAME IS ALMOST OVER SO IT'S TIME YOU ACKNOW-LEDGE ME. DO YOU WANT TO FALL NOT EVER KNOWING WHO TOOK YOU?
DESTROY SUPERABUNDANCE. STARVE THE FLESH, SHAVE THE HAIR, EXPOSE THE BONE, CLARIFY THE MIND, DEFINE THE WILL, RESTRAIN THE SENSES, LEAVE THE FAMILY, FLEE THE CHURCH, KILL THE VERMIN, VOMIT THE HEART, FORGET THE DEAD. LIMIT TIME, FOREGO AMUSEMENT, DENY NATURE, REJECT ACQUAINTANCES, DISCARD OBJECTS, FORGET TRUTHS, DISSECT MYTH, STOP MOTION, BLOCK IMPULSE, CHOKE SOBS, SWALLOW CHATTER. SCORN JOY, SCORN TOUCH, SCORN TRAGEDY, SCORN LIBERTY, SCORN CONSTANCY, SCORN HOPE, SCORN EXALTATION, SCORN REPRODUCTION, SCORN VARIETY, SCORN EMBELLISHMENT, SCORN RELEASE, SCORN REST, SCORN SWEETNESS, SCORN LIGHT. IT'S A QUESTION OF FORM AS MUCH AS FUNCTION. IT IS A MATTER OF REVULSION.

Selected One-Person Exhibitions:
Galerie Rüdiger Schöttle, Munich, 1980; Galerie Claude Rutault, Paris, 1980; Museum für (Sub)Kultur, Berlin, 1981; Nouveau Musée, Lyon, 1981; Galerie Chantal Crousel, Paris, 1982; Barbara Gladstone Gallery, N.Y.C., 1982; Times Square, N.Y.C., 1982; Artists Space, N.Y.C., 1982.

Selected Group Exhibitions:
Los Angeles Institute of Contemporary Art, "Artwords and Bookworks," 1978; P.S.1, Institute for Art and Urban Resources, Long Island City, 1978; Anthology Film Archives, N.Y.C., 1978; 5 Bleecker Street, N.Y.C., "Income and Wealth Show" and "Manifesto Show," 1979; 591 Broadway, N.Y.C., "Doctor and Dentist Show," 1979; "Art Festival of Parma," 1979; New Museum, N.Y.C., "Events: Fashion Moda," 1979; Printed Matter, N.Y.C., 1979; N.Y.C., "Show/515 Broadway," 1979; David Amico Gallery, L.A., "Works by Nine Artists," 1979, and "Pleasure/Function," 1980; Franklin Furnace, N.Y.C., "Vigilance," 1980; Anna Leonowens Gallery, Nova Scotia College of Art and Design, Halifax, "The Offices," 1980; 112 Workshop, N.Y.C., "The Offices," 1980; N.Y.C., "The Times Square Show," 1980; Grand Central Station, N.Y.C., "Project Grand Central," 1980; Kunsthaus Zurich, "New York Video," 1980; Städtische Galerie im Lenbachhaus, Munich, "New York Video," 1980; Brooke Alexander, Inc., N.Y.C., "Collaborative Projects," 1980; Lisson Gallery, London, "14 New Artists," 1980; Institute of Contemporary Arts, London, "Issue," 1980; Mudd Club, N.Y.C., "Beware of the Dog," 1981; Kitchen, N.Y.C., "Pictures and Promises" and "Pictures Lie," 1981; Chrysler Museum, Norfolk, "Crimes of Compassion," 1981; Museen der Stadt Köln, "Heute: Westkunst," 1981; Young-Hoffman Gallery, Chicago, "A New Sensibility," 1982; Marine Midland Bank, N.Y.C., "Art Lobby," 1982; Kassel, "Documenta 7," 1982.

Selected Bibliography:
D. Graham, "Signs," Artforum 19 (Apr. 1981): 38-9.

Bryan Hunt

Born in Terre Haute, Indiana, 1947
Lives in New York City

To me what sculpture is is creating, constructing, carving, modeling, pouring—a process or a conceptualization of mass. When you think in and translate mass, there is gravity to deal with. You want to release mass, and give it a life and a definition of its own, which I think good sculpture can do. Motion is part of the equation of it, not that it has to seem like it's in motion, but that is has potential motion or that it has the potential of a life of its own.

Selected One-Person Exhibitions:
Clocktower, Institute for Art and Urban Resources, N.Y.C., 1974; Jack Glenn Gallery, Corona del Mar, Ca., 1974; Palais des Beaux-Arts, Brussels, 1975; Daniel Weinberg Gallery, S.F., 1976, 78; Blum/Helman Gallery, N.Y.C., 1977-79, 81; Greenberg Gallery, St. Louis, 1978; Bernard Jacobson Gallery, London, 1979; Galerie Bischofberger, Zurich, 1979;

Margo Leavin Gallery, L.A., 1980; Akron Art Museum, 1981; Galerie Hans Strelow, Düsseldorf, 1981.

Selected Group Exhibitions:
Portland Center for the Visual Arts, Or., "Via Los Angeles," 1976; Willard Gallery, N.Y.C., "Selections," 1976; P.S.1, Institute for Art and Urban Resources, Long Island City, 1977; Daniel Weinberg Gallery, N.Y.C., "Up Against the Wall," 1978; Vassar College Art Gallery, Poughkeepsie, "Hunt, Lane, Jenney, Shapiro, Rothenberg," 1978; Solomon R. Guggenheim Museum, N.Y.C., "Young American Artists," 1978; Stedelijk Museum, Amsterdam, "Made by Sculptors," 1978; Katonah Gallery, N.Y., "Removed Realities: Aycock, Butterfield, Hunt, Shapiro," 1979; Whitney Museum of American Art, N.Y.C., "Biennial Exhibition," 1979, 81, and "The Decade in Review," 1979; Renaissance Society at the University of Chicago, "Visionary Images," 1979; Hayden Gallery, Massachusetts Institute of Technology, Cambridge, "Corners," 1979; Museum of Modern Art, N.Y.C., "Selections from the Collection—Contemporary Sculpture," 1979; University Gallery, University of Massachusetts, Amherst, "Sculpture on the Wall," 1980; San Francisco Museum of Modern Art, "Twenty American Artists," 1980; Thomas Segal Gallery, Boston, "Black and White," 1980; "39th Venice Biennale," 1980; Indianapolis Museum of Art, "Painting and Sculpture Today, 1980," 1980; Hamilton Gallery, N.Y.C., "Bronze," 1981; Contemporary Arts Museum, Houston, "The Americans: The Landscape," 1981; Akron Art Museum, "The Image in American Painting and Sculpture: 1950-1980," 1981; Cleveland Museum of Art, "Contemporary Artists," 1981; Blum/Helman Gallery, N.Y.C., "Bryan Hunt, Neil Jenney, Robert Moskowitz, Donald Sultan," 1981.

Selected Bibliography:
J. Siegel, "Bryan Hunt," Arts Magazine 51 (May 1977): 20; D.W. Reed, "Bryan Hunt," Arts Magazine 53 (Apr. 1979): 7; R. White, "Bryan Hunt: Interview," View 3 (Apr. 1980); D.W. Reed, "Bryan Hunt," Flash Art 104 (Oct./Nov. 1981): 49-51; R. Becker, "Bryan Hunt," Interview 12 (Jan. 1982): 52-4.

John Knight

Born in Los Angeles, California, 1945
Lives in Santa Monica, California

(Artist preferred to list only first and most recent exhibitions to place himself historically in time and to include only one bibliographical reference.)

Selected Group Exhibitions:
Allen Memorial Art Museum, Oberlin College, "Art in the Mind," 1970; Kassel, "Documenta," 1972, 82.

Selected Bibliography:
J. Knight, 14 September—16 October 1977, L.A., Otis Art Institute of Parsons School of Design, 1977.

Barbara Kruger

Born in Newark, New Jersey, 1945
Lives in New York City

I am interested in a secular art which connects the allowances of anthropology

with the intimacies of a cottage industry. I replicate certain pictures and words and watch them stray or coincide with the notions of fact and fiction. Perhaps this can result in an alternation between implicit and explicit, between inference and declaration. I think about assumption, disbelief and authority, but there are no "correct" readings. Only representations which strain the appearance of naturalism. I like to couple the ingratiation of wishful thinking with the criticality of knowing better.

Selected One-Person Exhibitions:
Artists Space, N.Y.C., 1974; Fischbach Gallery, N.Y.C., 1975; John Doyle Gallery, Chicago, 1976; Franklin Furnace, N.Y.C., 1979; Printed Matter Window, N.Y.C., 1979; ARC, Seattle, 1980; P.S.1, Institute for Art and Urban Resources, Long Island City, 1980; Hallwalls/CEPA Gallery, Buffalo, 1982; Larry Gagosian Gallery, L.A., 1982.

Selected Group Exhibitions:
Whitney Museum of American Art, N.Y.C., "1973 Biennial Exhibition"; Basel Art Fair, 1974; Florida State University, Tallahassee, "Thickening Surface," 1976; Grey Art Gallery and Study Center, New York University, "Thinking Drawings," 1976; NAME Gallery, Chicago, "Daley's Tomb," 1977, "7 x 9" and "False Face," 1978; San Francisco Art Institute, "1977 California Annual"; Ohio State University, Columbus, 1977; Artists Space, N.Y.C., "A Sound Selection: Audio Works by Artists," 1978; Federal Plaza, N.Y.C., "Private Views for the Public," 1979; 5 Bleecker Street, N.Y.C., "Manifesto Show," 1979; Rosa Esman Gallery, N.Y.C., "Object/Image/Text," 1979; University of Hartford, "Imitation of Life," 1979; Padiglione d'Arte Contemporanea, Milan, "Four Different Photographers," 1980; Cooper Union, N.Y.C., "Room, Window, Furniture," 1981; Group Material, N.Y.C., "Gender," 1981; Kitchen, N.Y.C., "Pictures and Promises," 1981; Solomon R. Guggenheim Museum, N.Y.C., "19 Emergent Artists," 1981; Josef Gallery, N.Y.C., "Moonlighting," 1981; Castelli Graphics, N.Y.C., "Love is Blind," 1981; Palazzo Rosso, Genoa, "Il Gergo Inquieto: Recent Photography," 1981; Wiener Secession, Vienna, "Extended Photography, 5th International Biennial," 1981; Annina Nosei Gallery, N.Y.C., "Public Address," 1981; Renaissance Society at the University of Chicago, "Art and the Media," 1982; Kassel, "Documenta 7," 1982.

Selected Bibliography:
Four Different Photographers, catalogue of exhibition organized by the Padiglione d'Arte Contemporanea, Milan, 1980 (text by C. Squiers); *Inespressionismo americano*, ed. by G. Celant, Genoa: Bonini Editore, 1981; *Extended Photography, 5th International Biennial*, catalogue of exhibition organized by the Wiener Secession, Vienna, 1982 (text by A. Auer and D. Weibel).

Sherrie Levine

Born in Hazelton, Pennsylvania, 1947
Lives in New York City

The world is filled to suffocating. Man has placed his token on every stone.

Every word, every image is leased and mortgaged. We know that a picture is but a space in which a variety of images, none of them original, blend and clash. A picture is a tissue of quotations drawn from the innumerable centers of culture. Similar to those eternal copyists Bouvard and Pechuchet, we indicate the profound ridiculousness that is precisely the truth of painting. We can only imitate a gesture that is always anterior, never original. Succeeding the painter, the plagiarist no longer bears within him passions, humours, feelings, impressions, but rather this immense encyclopedia from which he draws. The viewer is the tablet on which all the quotations that make up a painting are inscribed without any of them being lost. A painting's meaning lies not in its origin, but in its destination. The birth of the viewer must be at the cost of the painter.

Selected One-Person Exhibitions:
de Saisset Art Gallery and Museum, Santa Clara, Ca., 1974; 3 Mercer Street, N.Y.C., 1977-78; Hallwalls, Buffalo, 1978; Kitchen, N.Y.C., 1979; Merinoff Studio, N.Y.C., 1981; A Picture Is No Substitute for Anything, N.Y.C., 1981; Metro Pictures, N.Y.C., 1981.

Selected Group Exhibitions:
Artists Space, N.Y.C., "Pictures," 1977; Studio d'Arte Cannaviello, Milan, "Recognizable Images," 1979; Castelli Graphics, N.Y.C., "Pictures, Photographs," 1979, and "Love Is Blind," 1981; Padiglione d'Arte Contemporanea, Milan, "Horror Pleni: Pictures in New York Today," 1980; New 57 Gallery, Houston, 1980; Metro Pictures, N.Y.C., 1980-81; Kitchen, N.Y.C., "Pictures and Promises," 1980; P.S.1, Institute for Art and Urban Resources, Long Island City, "Couches, Diamonds and Pie," 1981; Museo di Sant'Agostino, Genoa, "Il Gergo Inquieto: Idola," 1981; Nigel Greenwood Ltd., London, 1981; Wiener Secession, Vienna, "Extended Photography, 5th International Biennial," 1981; Kassel, "Documenta 7," 1982.

Selected Bibliography:
D. Crimp, *Pictures*, catalogue of exhibition organized by Artists Space, N.Y.C., 1977; D. Crimp, "The Photographic Activity of Postmodernism," *October*, no. 15 (Winter 1980): 98-9; R. Krauss, "The Originality of the Avant-Garde: A Postmodernist Repetition," *October*, no. 18 (Fall 1981): 64-6; *Inespressionismo americano*, ed. by G. Celant, Genoa: Bonini Editore, 1981.

Sol LeWitt

Born in Hartford, Connecticut, 1928
Lives in New York City

Selected One-Person Exhibitions:
Dwan Gallery, N.Y.C., 1966-71; Galerie Konrad Fischer, Dusseldorf, 1968-69, 71, 72, 75, 77, 79, 81; Galerie Bischofberger, Zurich, 1968-69; Galerie Heiner Friedrich, Munich, 1968, 70; Ace Gallery, L.A., 1968, 74; Art & Project, Amsterdam, 1970-73, 75; Galerie Yvon Lambert, Paris, 1970, 73-74, 79, 81; Galleria Sperone, Turin, 1970, 74-75; Lisson Gallery, London, 1970-71, 73-74, 77, 79; Gemeentemuseum, The Hague, 1970; Pasadena Art Museum, 1970; Galleria Toselli, Milan, 1971, 73; John Weber

Gallery, N.Y.C., 1971, 73-74, 77-78, 80; Hayden Gallery, Massachusetts Institute of Technology, Cambridge, 1972; Kunsthalle Bern, 1972; Gallery A-402, California Institute of the Arts, Valencia, 1972; Nova Scotia College of Art and Design, Halifax, 1972; Galerie MTL, Brussels, 1972-73, 76; Museum of Modern Art, Oxford, 1973, 77; Galleria Marilena Bonomo, Bari, 1973, 80, 82; Palais des Beaux-Arts, Brussels, 1974; Rijksmuseum Kröller-Müller, Otterlo, 1974; Stedelijk Museum, Amsterdam, 1974; Daniel Weinberg Gallery, S.F., 1974-75, 81; New York Cultural Center, N.Y.C., 1974; Scottish National Gallery of Modern Art, Edinburgh, 1975; Samangallery, Genoa, 1975, 77, 81; Annemarie Verna, Zurich, 1975, 81; Israel Museum, Jerusalem, 1975; Kunsthalle Basel, 1975; Visual Arts Museum, N.Y.C., 1976; Dag Hammarskjöld Plaza Sculpture Garden, N.Y.C., 1976; Kölnischer Kunstverein, Cologne, 1976; Wadsworth Atheneum, Hartford, 1976, 81; Stedelijk Van Abbemuseum, Eindhoven, 1976; Centre d'Art Contemporain, Geneva, 1976; Art Gallery of New South Wales, Sydney, 1977; National Gallery of Victoria, Melbourne, 1977; Joslyn Art Museum, Omaha, 1977; Art and Architecture Gallery, Yale School of Art, New Haven, 1977; University Gallery, University of Massachusetts, Amherst, 1977; Museum of Modern Art, N.Y.C., 1978; Brooklyn Museum, 1978; Halle für Internationale Neue Kunst, Zurich, 1978; Young-Hoffman Gallery, Chicago, 1979-80; Galleria Ugo Ferranti, Rome, 1980, 82; Akron Art Institute, Ohio, 1980; Palace of Culture, Warsaw, 1981; University Art Gallery, New Mexico State University, Las Cruces, 1981; Illinois Institute of Technology, Chicago, 1982.

Selected Group Exhibitions:
Institute of Contemporary Art, Boston, "Multiplicity," 1966; Jewish Museum, N.Y.C., "Primary Structures," 1966; Finch College Museum of Art, N.Y.C., "Art in Process," 1966, and "Art in Series," 1967; Los Angeles County Museum of Art, "American Sculpture of the Sixties," 1967; Gemeentemuseum, The Hague, "Minimal Art," 1968; Kassel, "Documenta," 1968, 72, 82; Museum of Modern Art, N.Y.C., "The Art of the Real," 1968, "Information," 1970, "Some Recent American Art," 1974, "Color as Language," and "American Art Since 1945: From the Collection of MoMA," 1975, "Drawing Now," 1976, "Printed Matter," 1980, "Recent Acquisitions: Drawings," 1981, "A Century of Drawing," 1982; Kunsthalle, Düsseldorf, "Prospect '68," 1968; Kölnischer Kunstverein, "Kunstmarkt," 1968; Kunsthalle Bern, "When Attitudes Become Form," 1969; Whitney Museum of American Art, N.Y.C., "American Contemporary Sculpture," 1969, "200 Years of American Sculpture," 1976, "The Decade in Review," 1979; Krannert Art Museum, University of Illinois, Champaign, "Contemporary American Painting and Sculpture," 1969; Schloss Morsbroich, Städtisches Museum, Leverkusen, "Konzeption/Conception," 1969; La Jolla Museum of Contemporary Art, "Projections: Anti-Materialism," 1970; Galleria Civica d'Arte Moderna, Turin, "Conceptual Art/Arte Povera/Land

Art," 1970; Milwaukee Art Center, "New Directions: Eight Artists," 1971; Institute of Contemporary Art of the University of Pennsylvania, Philadelphia, "Grids," 1972; New York Cultural Center, "3D into 2D: Drawing for Sculpture," 1973; Parcheggio di Villa Borghese, Rome, "Contemporanea," 1973; Art Museum, Princeton University, "Line as Language: Six Artists Draw," 1974; Corcoran Gallery of Art, Washington, D.C., "34th Biennial of Contemporary American Painting," 1975; School of Visual Arts, N.Y.C., "Lines," 1976; Art Institute of Chicago, "72nd American Exhibition," 1976, and "73rd American Exhibition," 1979; Rosa Esman Gallery, N.Y.C., "Photonotations," 1976, "Photonotations II," 1977, "The Geometric Tradition in American Painting: 1920-1980," 1980; "37th Venice Biennale," 1976; Detroit Institute of Arts, "American Artists: A New Decade," 1976; Aldrich Museum of Contemporary Art, Ridgefield, Ct., "Prospectus: The Seventies" and "The Minimal Tradition," 1979, "New Dimensions in Drawing," 1981; Hudson River Museum, Yonkers, "Super Show," 1979; Joe & Emily Lowe Art Museum, Syracuse University, "Current/New York," 1980; Hayward Gallery, London, "Pier & Ocean," 1980; Institut für Visuelle Gestaltung, Linz, "Forum Design," 1980; Arts Council of Great Britain, London, "Artist and Camera," 1980, and "Big Prints," 1982; Grey Art Gallery and Study Center, New York University, "Perceiving Modern Sculpture: Selections for the Sighted and Non-Sighted," 1980; Hayden Gallery, Massachusetts Institute of Technology, Cambridge, "Artists' Gardens and Parks—Plans, Drawings and Photographs," 1981; Museen der Stadt Köln, "Westkunst," 1981; Musée National d'Art Moderne, Centre Georges Pompidou, Paris, "Murs," 1981; Stedelijk Museum, Amsterdam, "'60-'80," 1982.

Selected Bibliography:
Sol LeWitt, catalogue of exhibition organized by the Museum of Modern Art, N.Y.C., 1978 (intro. by A. Legg; essays by L. Lippard, B. Rose, R. Rosenblum; commentaries and writings by S. LeWitt; extensive bibliog.); S. LeWitt, *Autobiography*, N.Y.C. and Boston: Multiples, Inc. and Lois and Michael K. Torf, 1980; A.S. Wooster, "LeWitt's Expanding Grid," *Art in America* 68 (May 1980): 143-7; C. Ratcliff, "Modernism and Melodrama," *Art in America* 69 (Feb. 1981): 105-9; *Sol LeWitt*, catalogue of exhibition organized by the Wadsworth Atheneum, Hartford, 1982 (at press).

Robert Mangold

Born in North Tonawanda, New York, 1937
Lives in New York City

When I started to work on *Painting For Three Walls*, the following were some of my thoughts:

I wanted to work on a mural type painting, a portable mural.

The mural idea interested me because of the controlled interaction between the works, the space and the viewer, which was a more complicated set of tension relationships than I could deal with in a single work.

The work would create the space rather than the artist as a kind of decorator in a pre-determined space.

Gallery spaces seem to be designed for movement—people or eye flow. I wanted more static space which would be more useful for positioning oneself for the viewing of the work.

The work would have one painting covering a large portion but not all of each wall, surrounding the viewer and preventing the viewing of any painting singly without the felt presence of the adjoining painting and yet a work that could be seen together.

Selected One-Person Exhibitions:
Thibaut Gallery, N.Y.C., 1964; Fischbach Gallery, N.Y.C., 1965, 67, 69-71, 73; Galerie Müller, Stuttgart, 1968; Solomon R. Guggenheim Museum, N.Y.C., 1971; Galerie Yvon Lambert, Paris, 1973, 76; Galleria Toselli, Milan, 1973; Lisson Gallery, London, 1973, 75, 81; Galerie Annemarie Verna, Zurich, 1973, 78, 81; Galleria Marilena Bonomo, Bari, 1973; Max Protetch Gallery, Washington, D.C., 1973; Daniel Weinberg Gallery, S.F., 1973; John Weber Gallery, N.Y.C., 1974, 76-77, 79-80; La Jolla Museum of Contemporary Art, 1974; Galerie Konrad Fischer, Düsseldorf, 1974, 76, 79; Cusack Gallery, Houston, 1975; Ace Gallery, L.A., 1975; Galerie Swart, Amsterdam, 1976; Galleria d'Allessandro Ferranti, Rome, 1976; Museum Haus Lange, Krefeld, 1977; Portland Center for the Visual Arts, Or., 1977; Kunsthalle Basel, 1977; Young-Hoffman Gallery, Chicago, 1977, 80; Bernier Gallery, Athens, 1978; Yarlow/Salzman Gallery, Toronto, 1978; Studio La Città, Verona, 1978; Galerie Schellmann & Kluser, Munich, 1978; Protetch-McIntosh Gallery, Washington, D.C., 1978; INK, Zurich, 1978; Kunsthalle Bielefeld, 1980; Texas Gallery, Houston, 1980; Hoshour Gallery, Albuquerque, 1981; Carol Taylor Art, Dallas, 1981.

Selected Group Exhibitions:
Solomon R. Guggenheim Museum, N.Y.C., "Systematic Painting," 1966, "American Postwar Painting in the Guggenheim Collection," 1977, "From the Collection 1900-1980," 1980; Institute of Contemporary Art of the University of Pennsylvania, Philadelphia, "A Romantic Minimalism," 1967; Aldrich Museum of Contemporary Art, Ridgefield, Ct., "Cool Art" and "Highlights of the 1967-68 Season," 1968; "The Minimal Tradition," 1979, "New Dimensions in Drawing," 1981; Whitney Museum of American Art, N.Y.C., "Recent Acquisitions," 1970, "Drawing Now" and "Printsequence," 1976, "Gifts of Drawings," 1979; Albright-Knox Art Gallery, Buffalo, "Modular Paintings," 1970, and "American Painting of the 1970's," 1978; Kassel, "Documenta," 1972, 77; Baltimore Museum of Art, "Fourteen Artists," 1975, and "Contemporary Abstract Art: Works on Paper," 1976; Städtisches Museum, Monchengladbach, "Graphic Work," 1975; Städtisches Museum, Leverkusen, "Zeichnungen 3," 1975; Musée d'Art Moderne de la Ville de Paris, "Tendances Actuelles de la Nouvelle Peinture Americaine," 1975; Visual Arts Museum, N.Y.C., "Line," 1976, and "Shaped Paintings," 1979; Museum of Contemporary Art, Chicago, "A View of a Decade," 1977; Brooklyn

Museum, "Prints in Series," 1977, and "American Drawing in Black & White," 1980; Joe & Emily Lowe Art Gallery, Syracuse University, "Critic's Choice," 1977, and "All in Line," 1980; Worcester Art Museum, "Two Decades of American Printmaking: 1957-1977," 1978; University of South Florida, Tampa, "Two Decades of Abstraction—New Abstraction," 1979, and "Selections from the John Weber Gallery, New York City," 1981; Ackland Art Museum, University of North Carolina, Chapel Hill, "Drawings About Drawings: New Directions (1968-1978)," 1979; Institute of Contemporary Art, Boston, "The Reductive Object—Survey of the Minimal Aesthetic in the 1960's," 1979; Renaissance Society at the University of Chicago, "Monochrome," 1979; Stedelijk Museum, Amsterdam, "Acquisitions 1974-1978, Painting & Sculpture," 1980; Yale University Art Gallery, New Haven, "Twenty Artists, Yale School of Art, 1950-1970," 1981; University Gallery, Fine Arts Center, University of Massachusetts, Amherst, "Selections from the Chase Manhattan Bank Art Collection," 1981; Wesleyan University, Middletown, Ct., "No Title, The Collection of Sol LeWitt," 1981.

Selected Bibliography:
R. Krauss, "Interview with Robert Mangold," and J. Masheck, "A Humanist Geometry," *Artforum* 12 (Mar. 1974): 36-43; R. White, "Robert Mangold: Interview," *View* 1 (Dec. 1978); *Robert Mangold Gemälde*, catalogue of exhibition organized by the Kunsthalle Bielefeld, 1980 (text by H. Heere and B. Kerber); *Robert Mangold—Painting for Three Walls*, catalogue of exhibition organized by the John Weber Gallery, N.Y.C., 1980 (essay by N. Spector); T. Bell, "Robert Mangold," *Arts Magazine* 54 (Mar. 1980): 3.

Robert Moskowitz

Born in New York City, 1935
Lives in New York City

Selected One-Person Exhibitions:
Leo Castelli Gallery, N.Y.C., 1962; French & Company, N.Y.C., 1970; Hayden Gallery, Massachusetts Institute of Technology, Cambridge, 1971; Nancy Hoffman Gallery, N.Y.C., 1973-74; Clocktower, Institute for Art and Urban Resources, N.Y.C., 1977; Daniel Weinberg Gallery, S.F., 1979-80; Margo Leavin Gallery, L.A., 1979-81; Walker Art Center, Minneapolis, 1981; Hudson River Museum, Yonkers, 1981.

Selected Group Exhibitions:
Museum of Modern Art, N.Y.C., "The Art of Assemblage," 1961, and "Painting and Sculpture—New Acquisitions," 1962; Sidney Janis Gallery, N.Y.C., "New Realists," 1962; Albright-Knox Art Gallery, Buffalo, "Mixed Media and Pop Art," 1963, and "American Painting of the 1970's," 1978; Brandeis University, Waltham, "New Directions in American Painting," 1963; Oakland Museum, "Pop Art," 1963; Wadsworth Atheneum, Hartford, "Black, White and Grey," 1964; Washington (D.C.) Gallery of Modern Art, 1964; Wesleyan University, Middletown, Ct. "New York," 1964; School of Visual Arts, N.Y.C., "Working Drawings," 1967, and "Invisible Art,"

1969; Galerie Heiner Friedrich, Munich, "Drawings," 1968; Whitney Museum of American Art, N.Y.C., "1969 Annual Exhibition," "Biennial Exhibition," 1973, 79, 81, "New Image Painting," 1978, and "The Decade in Review," 1979; Finch College, Museum of Art, N.Y.C., "Artists at Work," 1971; Art Institute of Chicago, Society for Contemporary Art, "The Small Scale in Contemporary Art," 1975; Paula Cooper Gallery, N.Y.C., 1976-77; Protetch-McIntosh Gallery, Washington, D.C., "The Minimal Image," 1978; Willard Gallery, N.Y.C., 1978; Renaissance Society at the University of Chicago, "Visionary Images," 1979; Grey Art Gallery and Study Center, New York University, "American Painting: The Eighties," 1979; "39th Venice Biennale," 1980; Padiglione d'Arte Contemporanea, Milan, "Horror Pleni: Pictures in New York Today," 1980; Blum/Helman Gallery, N.Y.C., "Bryan Hunt, Neil Jenney, Robert Moskowitz, Donald Sultan," 1981; Kunsthalle Basel, "Robert Moskowitz, Susan Rothenberg, Julian Schnabel," 1981.

Selected Bibliography:
New Image Painting, catalogue of exhibition organized by the Whitney Museum of American Art, N.Y.C., 1978 (text by R. Marshall, artists' statements); Robert Moskowitz: Recent Paintings, catalogue of exhibition organized by the Walker Art Center, Minneapolis, 1981 (text by L. Lyons); J. Silverthorne, "Robert Moskowitz," Artforum 20 (Nov. 1981): 84-5; L.R. Bofferding, "Robert Moskowitz," Arts Magazine 56 (Nov. 1981): 13; Robert Moskowitz, catalogue of exhibition organized by the Kunsthalle Basel, 1981 (text by P. Blum and M. Hurson).

Elizabeth Murray

Born in Chicago, Illinois 1940
Lives in New York City

Selected One-Person Exhibitions:
Jacob's Ladder Gallery, Washington, D.C., 1974; Paula Cooper Gallery, N.Y.C., 1975-76, 78, 81; Jared Sable Gallery, Toronto, 1975; Phyllis Kind Gallery, Chicago, 1978; Susanne Hilberry Gallery, Birmingham, Mi., 1980; Galerie Mukai, Tokyo, 1980.

Selected Group Exhibitions:
Whitney Museum of American Art, N.Y.C., "1972 Annual Exhibition," "Biennial Exhibition," 1973, 77, 79, 81, "American Abstract Painting Today" (Downtown), 1974, "The Decade in Review," 1981; John Doyle Gallery, Cologne, "Cologne Kunstmarkt," 1974; Galerie Doyle, Paris, 1974; Mellon Art Center, Wallingford, Ct., "Faculty Show, California Institute of the Arts," 1975; Hallwalls, Buffalo, "Looking at Painting," 1976; Fine Arts Building, N.Y.C., Scale," 1976; State University of New York, Brockport, "Recent Abstract Painting," 1976; California State University, L.A., "New Work/New York," 1976; Solomon R. Guggenheim Museum, N.Y.C., "Nine Artists: Theodoron Awards," 1977; Museum of Art, Rhode Island School of Design, Providence, "Space Window," 1977, and "Art for Your Collection XVIII," 1981; New York State Museum, Albany, "New York: The State of Art," 1977; Joe & Emily Lowe Art Gallery,

Syracuse University, "Critics' Choice," 1977; Museum of Contemporary Art, Chicago, "A View of a Decade," 1977; Institute of Contemporary Art of the University of Pennsylvania, Philadelphia, "Eight Abstract Painters," 1978; Tampa Bay Art Center, "Two Decades of Abstraction," 1978; Renaissance Society at the University of Chicago, "Thick Paint," 1978; William Patterson College, Wayne, N.J., "Some Abstract Paintings," 1979; Susan Caldwell Gallery, N.Y.C., "Generation," 1979; Hayward Gallery, London, "New Painting, New York," 1979; Grey Art Gallery and Study Center, New York University, "American Painting: The Eighties," 1979; Weatherspoon Art Gallery, University of North Carolina, Greensboro, "Art on Paper 1979"; University of Colorado Museum, Boulder, "Selections from a Colorado Collection," 1980; Galerie Yvon Lambert, Paris, "Paula Cooper at Yvon Lambert," 1980; Brooklyn Museum, "American Drawing in Black and White, 1970-1980," 1980; Contemporary Arts Center, Cincinnati, "The R.S.M. Collection," 1981; High Museum of Art, Atlanta, "Drawings from Georgia Collections, 19th and 20th Centuries," 1981; Galerie Mukai, Tokyo, "Drawings," 1981; University Gallery, Fine Arts Center, University of Massachusetts, Amherst, "Selections from the Chase Manhattan Bank Art Collection," 1981; Virginia Museum of Fine Arts, Richmond, "Art in Our Time," 1981; Haus der Kunst, Munich, "American Painting, 1930-1980," 1981; Jacksonville Art Museum, Inc., "Group Show," 1981; Hamilton Gallery, N.Y.C., "The Abstract Image," 1982.

Selected Bibliography:
D.B. Kuspit, "Elizabeth Murray's Dandyish Abstraction," Artforum 16 (Feb. 1978): 28-31; J. Perone, "Elizabeth Murray," Artforum 17 (Jan. 1979): 65-6; American Painting: The Eighties, catalogue of exhibition curated by B. Rose at the Grey Art Gallery and Study Center, New York University, 1979; J. Murry, "Quintet: The Romance of Order and Tension in Five Paintings by Elizabeth Murray," Arts Magazine 55 (May 1981): 102-5; D. Phillips, "Elizabeth Murray at Paula Cooper," Images and Issues 2 (Summer 1981): 46-9.

Bruce Nauman

Born in Fort Wayne, Indiana, 1941
Lives in Pecos, New Mexico

Selected One-Person Exhibitions:
Nicholas Wilder Gallery, L.A., 1966, 68, 70, 77; Leo Castelli Gallery, N.Y.C., 1968-69, 71, 73, 75-76, 78, 80, 82; Sacramento State College Art Gallery, 1968; Galerie Konrad Fischer, Düsseldorf, 1968-70, 74-75, 78, 80-81; Galerie Sonnabend, Paris, 1969-70; Galleria Sperone, Turin, 1970; Galerie Bischofberger, Zurich, 1970; San Jose State College, Ca., 1970; Galerie Françoise Lambert, Milan, 1971; Ace Gallery, Vancouver, 1971, 74, 76, 78; Los Angeles County Museum of Art, 1972; University of California, Irvine, 1973; Art in Progress, Munich, 1974; Wide White Space, Antwerp, 1974; Albright-Knox Art Gallery, Buffalo, 1975; University of Nevada Art Gallery, Las Vegas, 1976;

Sonnabend Gallery, N.Y.C., 1976; Sperone Westwater Fischer, N.Y.C., 1976, 82; College Gallery, Minneapolis Institute of Arts, 1978; Halle für Internationale Neue Kunst, Zurich, 1978, 81; Galerie Schmela, Düsseldorf, 1979; Marianne Deson Gallery, Chicago, 1979; Portland Center for the Visual Arts, Or., 1979; Hester von Royen Gallery, London, 1979; Hill's Gallery, Santa Fe, 1980; Carol Taylor Art, Dallas, 1980; Nigel Greenwood Ltd., London, 1981; Rijksmuseum Kröller-Müller, Otterlo, 1981; Young-Hoffman Gallery, Chicago, 1981; Maud Boreel Punt Art, The Hague, 1981.

Selected Group Exhibitions:
San Francisco Museum of Art, "New Directions," 1966, and "Painting and Sculpture in California: The Modern Era," 1976; Los Angeles County Museum, "American Sculpture of the 60's," 1967, and "Seventeen Artists in the Sixties, The Museum of Site: Sixteen Projects," 1981; Kassel, "Documenta," 1968, 72, 82; Leo Castelli Warehouse, N.Y.C., "9 at Leo Castelli," 1968; American Federation of Arts, N.Y.C., "Soft & Apparently Soft Sculpture," 1968; Kunsthalle Bern, "When Attitudes Become Form," 1969; Stedelijk Museum, Amsterdam, "Op Losse Schroeven," 1969, "Air," 1971, "Made by Sculptors," 1978; Solomon R. Guggenheim Museum, N.Y.C., "9 Young Artists: Theodoran Awards," 1969, and "6th Guggenheim International Exhibition," 1971; Whitney Museum of American Art, N.Y.C., "Anti-Illusion: Materials/Procedures," 1969, "1970 Annual Exhibition of Contemporary Sculpture," "Films by Artists," 1972, "Autogeography" (Downtown) and "200 Years of American Sculpture," 1976, "1977 Biennial Exhibition," "20th Century American Drawings: Five Years of Acquisitions," 1978, "New American Filmmakers Series," 1980; Museum of Contemporary Art, Chicago, "Art by Telephone," 1969, "Holograms & Lasers," 1970, "Menace" and "Body Works," 1975, "Words at Liberty" and "A View of a Decade," 1977; Finch College Museum of Art, N.Y.C., "Art in Process" and "N Dimensional Space," 1970, "Projected Art: Artist at Work," 1971; New York Cultural Center, N.Y.C., "Conceptual Art and Conceptual Aspects," 1970, "3D into 2D: Drawing for Sculpture," 1973; Princeton University Art Museum, "American Art Since 1960," 1970; Museum of Modern Art, N.Y.C., "Information," 1970; Institute of Contemporary Art of the University of Pennsylvania, Philadelphia, "Against Order: Chance and Art," 1970, and "Drawing Now," 1975; New York University, "Body," 1971; Hayward Gallery, London, "11 L.A. Artists," 1971, and "Pier & Ocean," 1980; Albright-Knox Art Gallery, Buffalo, "Kid Stuff," 1971; Moore College of Art, Philadelphia, "Recorded Activities," 1971; Rijksmuseum Kröller-Müller, Otterlo, "Diagrams and Drawings," 1972; Art Institute of Chicago, "Idea and Image in Recent Art," 1974, "72nd American Exhibition," 1976, "73rd American Exhibition," 1979; Musée National d'Art Moderne, Centre Georges Pompidou, Paris, "Art/Voir," 1974; Ackland Art Museum, University of North Carolina, Chapel Hill, "Light/Sculpture," 1975;

Schloss Morsbroich, Städtisches Museum, Leverkusen, "Zeichnungen 3," 1975; National Collection of Fine Arts, Washington, D.C., "Sculpture, American Directions 1945-1975," 1975; Detroit Institute of Arts, "American Artists: A New Decade," 1976; Renaissance Society at the University of Chicago, "Ideas on Paper 1970-76," 1976, and "Ideas in Sculpture 1965-1977," 1977; "38th Venice Biennale," 1978; Museum Bochum, Germany, "Words Words," 1979; Museum Haus Lange, Krefeld, "The Broadening of the Concept of Reality in the Art of the 60s and 70s," 1979, and "Zeichnungen Neuereverbungen 1976-80," 1980; Allen Memorial Art Museum, Oberlin College, "From Reinhardt to Christo," 1980; Los Angeles Institute of Contemporary Art, "Architectural Sculpture," 1980; Aldrich Museum of Contemporary Art, Ridgefield, Ct., "New Dimensions in Drawing," 1981; D.C. Space for Washington Project for the Arts, "Neon Fronts: Luminous Art for the Urban Landscape," 1981; Neuberger Museum, State University of New York, Purchase, "Soundings," 1981; Louisiana Museum, Denmark, "Drawing Distinctions," 1981.

Selected Bibliography:
J. Butterfield, "Bruce Nauman, the Center of Yourself," *Arts Magazine* 49 (Feb. 1975): 53-5; J. Price, "Video Art: A Medium Discovering Itself," *Art News* 76 (Jan. 1977): 44-5; J. Perone, "Bruce Nauman," *Artforum* 15 (Jan. 1977): 58-60; *Bruce Nauman, 1972-1981*, catalogue of exhibition organized by the Rijksmuseum Kröller-Müller, Otterlo, 1981 (text by K. Schmidt, E. Joosten, S. Holsten).

Katherine Porter

Born in Cedar Rapids, Iowa, 1941
Lives in Lincolnville, Maine

While working on these pictures I try to tell of what is and what can be—

to have the meanings understood by the abstraction, color, symbols, the way the paint is put down. I would like to have these pictures be as clear and as full as a novel by Camus, poems by Neruda, and Beethoven's Third Symphony. In *San Salvador* I tried to paint a past, a tragic present, an unknown future.

Selected One-Person Exhibitions:
Parker 470 Gallery, Boston, 1971-72; University of Rhode Island, Kingston, 1971; Henri Gallery, Washington, D.C., 1972; Worcester Art Museum, 1973; Hayden Gallery, Massachusetts Institute of Technology, Cambridge, 1974; David McKee Gallery, N.Y.C., 1975, 78-81; Alpha Gallery, Boston, 1979; Achenbach Foundation, San Francisco Museum of Modern Art, 1980; Dartmouth College Museum and Galleries, Hanover, 1981.

Selected Group Exhibitions:
Finch College Museum of Art, N.Y.C., "Betty Parsons Collection," 1967; Institute of Contemporary Art, Boston, "Collaboration," 1969, and "Drawings Re-Examined," 1970; Parker 470 Gallery, Boston, "Insights," 1969; Obelisk Gallery, Boston, "Three If By Air," 1969; Studio Coalition, Boston, 1970; Hayden Gallery, Massachusetts Institute of Technology, Cambridge, "Six Artists," 1970;

Thayer Academy, Braintree, Ma., "Twelve from around Town," 1972; Whitney Museum of American Art, N.Y.C., "Biennial Exhibition," 1973, 81; Institute of Contemporary Art of the University of Pennsylvania, Philadelphia, "Six Visions," 1973; Museum of Fine Arts, Boston, "Boston Collects Boston," 1973; Solomon R. Guggenheim Museum, N.Y.C., "Nine Artists: Theodoron Awards," 1977; Brandeis University, Waltham, "From Women's Eyes," 1971; Spoleto Festival U.S.A., Charleston, "Spoleto Choice," 1978; Milwaukee Art Center, 1978, "Art in Our Time: HHK Foundation for Contemporary Art, Inc.," 1980; Atlantic Gallery, Boston, 1978; Makler Gallery, Philadelphia, 1978; Rockland Center for the Arts, N.Y. "Works on Paper, U.S.A.," 1979; Otis Art Institute of Parsons School of Design, L.A., "New York—A Selection from the Last 10 Years," 1979; Cadman Plaza, Brooklyn, "New Options in Painterly Abstraction," 1979; Impressions Gallery, Boston, "Drawing Now," 1979; XIII Winter Olympic Games, Lake Placid, "American Painting," 1980; Hamilton Gallery, N.Y.C., "The Abstract Image," 1982.

Selected Bibliography:
H. O'Beil, "Katherine Porter," *Arts Magazine* 53 (June 1979): 21; P. Allara, "Boston: Shedding its Inferiority Complex," *Art News* 78 (Nov. 1979): 98-9; T. Lawson, "Katherine Porter, David McKee Gallery," *Artforum* 19 (May 1981): 71; D. McKee, "Katherine Porter," *Arts Magazine* 55 (June 1981): 25-6.

Stephen Prina

Born in Galesburg, Illinois, 1954
Lives in Los Angeles, California

"Keeping simply to modern times, the Russian Formalists, Propp and Lévi-Strauss have taught us to recognize the following dilemma: either a narrative is merely a rambling collection of events, in which case nothing can be said about it other than by referring back to the story-teller's (the author's) art, talent or genius—all mythical forms of chance[1]— or else it shares with other narratives a common structure which is open to analysis, no matter how much patience its formulation requires. There is a world of difference between the most complex randomness and the most elementary combinatory scheme, and it is impossible to combine (to produce) a narrative without reference to an implicit system of units and rules.

[1]There does, of course, exist an 'art' of the storyteller, which is the ability to generate narratives (messages) from the structure (the code). This art corresponds to the notion of *performance* in Chomsky and is far removed from the 'genius' of the author, romantically conceived as some barely explicable personal secret."
(from R. Barthes, "Introduction to the Structural Analysis of Narratives," in *Image—Music—Text*, essays selected and trans. by S. Heath, N.Y.C.: Hill and Wang, 1977: 80.)

"It is patent that these three notions—mathesis, taxinomia, genesis—designate not so much separate domains as a solid grid of kinships that defines the general configuration of knowledge in the Classi-

cal age. *Taxinomia* is not in opposition to mathesis: it resides within it and is distinguished from it; for it too is a science of order—a qualitative mathesis. But understood in the strict sense of mathesis is a science of equalities, and therefore of attributions and judgments; it is the science of *truth*. *Taxinomia*, on the other hand, treats identities and differences; it is the science of articulations and classifications; it is the knowledge of *beings*. In the same way, genesis is contained within *taxinomia*, or at least finds in it its primary possibility. But *taxinomia* establishes the table of visible differences; genesis presupposes a progressive series; the first treats of signs in their spatial simultaneity, as a syntax; the second divides them up into an analogon of time, as a chronology. In relation to mathesis, *taxinomia* functions as an ontology confronted by an apophantics; confronted by genesis, it functions as a semiology confronted by history. It defines, then, the general law of beings, and at the same time the conditions under which it is possible to know them."
(from M. Foucault, *The Order of Things* [trans. of *Les mots et les choses*, 1966], N.Y.C.: Vintage Books, 1973: 74.)

"...either the narrative is a simple hotch-potch of events, in which case it can only be discussed by referring it to the art, the talent or the genius of the narrator (the author)—all mythical forms of chance—or it shares with other narratives a structure which can be analysed, however much patience it may require; there is a deep gulf between the most complex product of chance and the simplest construction of the mind, and no one can build (produce) a narrative without reference to an implicit system of units and rules."
(from R. Barthes, cited by R. Coward and J. Ellis in "Semiology as a science of signs," *Language and Materialism*, London, 1977, and Binghamton, N.Y., 1980: 40.)

Selected One-Person Exhibitions:
Northern Illinois University, DeKalb, 1976; Carl Sandburg College, Galesburg, Ill., 1978; Galesburg Civic Art Center, 1978; California Institute of the Arts, Valencia, 1979-80.

Selected Group Exhibitions:
Galesburg Civic Art Center, "5 Artists," 1976; University of California, Irvine, "CalArts and Claremont at U.C. Irvine," 1978; Vancouver School of Art, "Group Exhibition of Some CalArts Works and Other People Who Have Passed Through," 1979; Addison Gallery of American Art, Phillips Academy, Andover, 1979; Claremont College, Ca., 1979; Ryder Gallery, Kroeber Hall, University of California, Berkeley, 1979; University of Hartford, 1979; Otis Art Institute of Parsons School of Design, L.A., 1979; New Museum, N.Y.C., "Investigations: Probe • Structure • Analysis," 1980.

Selected Bibliography:
Investigations: Probe • Structure • Analysis, catalogue of exhibition organized by the New Museum, N.Y.C., 1980 (text by L. Gumpert and A. Schwartzman); P. Serra Zanetti, "New Work/New York," *Meta*, no. 3 (Feb./Mar. 1981): n.p.

Martin Puryear

Born in Washington, D.C., 1941
Lives in Chicago, Illinois

Selected One-Person Exhibitions:
Grona Palletten Gallery, Stockholm, 1968; Fisk University, Nashville, 1972; Henri Gallery, Washington, D.C., 1972-73; Corcoran Gallery of Art, Washington, D.C., 1977; Protetch-McIntosh Gallery, Washington, D.C., 1978-79; Young-Hoffman Gallery, Chicago, 1980, 82; Museum of Contemporary Art, Chicago, 1980; Joslyn Art Museum, Omaha, 1980; Delahunty Gallery, Dallas, 1982; McIntosh-Drysdale Gallery, Washington, D.C., 1982.

Selected Group Exhibitions:
Baltimore Museum of Art, "1962 Annual Exhibition"; Adams-Morgan Gallery, Washington, D.C., "Puryear, Raymond, Termini," 1962; U.S.I.S. Gallery, Freetown, Sierra Leone, 1965; Swedish Royal Academy of Art, Stockholm, "Swedish Academy Annual Exhibition," 1967-68; Liljevalchs Konsthall, Stockholm, "1967 Stockholm Biennial Exhibition"; Lunn Gallery, Washington, D.C., 1969; University of Wisconsin, Madison, "Prints and Paintings by Black Artists," 1971; University of Maryland, College Park, "New Talent at Maryland," 1974; Artpark, Lewistown, N.Y., 1977; Museum of Art, Pennsylvania State University, University Park, "The Material Dominant," 1977; Solomon R. Guggenheim Museum, N.Y.C., "Young American Artists: 1978 Exxon National Exhibition"; Whitney Museum of American Art, N.Y.C., "The Presence of Nature," 1978, "Biennial Exhibition," 1979, 81; Protetch-McIntosh Gallery, Washington, D.C., "Art and Architecture, Space and Structure," 1979; U.S. Customs House on Bowling Green, N.Y., "Custom and Culture," 1979; Wave Hill Environmental Center and Sculpture Gardens, Bronx, "Wave Hill: The Artist's View," 1979; P.S.1, Institute for Art and Urban Resources, Long Island City, "Afro-American Abstraction," 1980; University of Illinois, Chicago Circle Campus, "The Black Circle," 1980; Contemporary Art Center, Cincinnati, "Chicago, Chicago," 1980; Chicago Council on Fine Arts, "City Sculpture," 1981; Oscarsson Hood Gallery, N.Y.C., "The New Spiritualism: Transcendent Images in Painting and Sculpture," 1981; Bell Gallery, Brown University, Providence, "Brown University Invitational Exhibition," 1982.

Selected Bibliography:
J. Crary, "Martin Puryear's Sculpture," Artforum 17 (Oct. 1979); 28-31; Options 2: Martin Puryear, catalogue of exhibition organized by the Museum of Contemporary Art, Chicago, 1980 (text by J. Russi Kirshner); I-80 Series: Martin Puryear, catalogue of exhibition organized by the Joslyn Art Museum, Omaha, 1980 (text by H. T. Day).

Martha Rosler

Born in Brooklyn, New York, 1943
Lives in Brooklyn, New York

The subject is the commonplace; I am trying to use video to question the mythical explanations of everyday life.

We accept the clash of public and private as natural, yet their separation is historical, and the antagonism of the two spheres, which have in fact developed in tandem, is an ideological fiction—a potent one. Capitalist development has occasioned a great flowering of individuality, along with great obstacles to the ideals of private life it has fostered. Our society's habit of erasing the ideas of history and contingency makes it difficult for us to understand our lives as social rather than merely private events, difficult to understand the causes of failures in either realm—or their cure.

I want to explore the relationships between individual consciousness, family life, and culture under capitalism, restoring some idea of the historical currents bringing the present moment into being. I construct "decoys" engaged in a dialectic with commercial TV, challenging the givens of life and culture. Secrets from the Street: No Disclosure presents, as anti-travelogue, the clash of street life and polite expectations as a matter of national culture and, preeminently, class. In Losing: A Conversation with the Parents, an impossibly young couple enacting an interview-of-the-bereaved focuses on food as a social weapon, both personal and global. The East Is Red, The West Is Bending is an absurdist late-night commercial in which a personal rendition of a corporate text betrays some foreign policy assumptions.

Selected One-Person Exhibitions:
Parachute Center for Cultural Affairs, Calgary, 1976; Long Beach Museum of Art, 1977; Arizona State University, Tempe, 1977; Whitney Museum of American Art, N.Y.C., 1977; and/or Gallery, Seattle, 1978; Véhicule Art, Montreal, 1978; Video Free America, S.F., 1978; Photography Gallery, Orange Coast College, Costa Mesa, Ca., 1979; A Space, Toronto, 1979; University Art Museum, Berkeley, 1979; Anna Leonowens Gallery, Nova Scotia College of Art and Design, Halifax, 1980; Hallwalls, Buffalo, 1982.

Selected Group Exhibitions:
San Diego State University, "Annual Women's Art Show," 1971, 73, "Bookworks," 1982; University of California, San Diego, "Exposure," 1972, "Images by Women," 1974; Musée des Arts Décoratifs, Lausanne, "Impact Art-Video Art," 1974; Palais des Beaux-Arts, Brussels, "Artists' Video Tapes," 1975; Long Beach Museum of Art, "Southland Video Anthology," 1975, and "Summer Video Archive Exhibition," 1978; Contemporary Arts Gallery, New York University, "First New York City Postcard Show," 1975; San Francisco Art Institute, "Information," 1975, and "Social Criticism and Art Practice," 1977; Israel Museum, Jerusalem, "Recycling Show," 1975; Dandelion Gallery, Calgary, "Exhibition of Mail Art," 1975; Arte Nuevo Gallery, Buenos Aires, "Last International Exhibition of Mail Art '75," 1975; Whitney Museum of American Art, N.Y.C., "Autogeography" (Downtown), 1975, "Out of the House" (Downtown), 1978, "1979 Biennial Exhibition"; Parachute Center for Cultural Affairs, Calgary, "Artists' Resumés," 1976; La Mamelle, Inc., S.F., "Televised Video Art," 1976; Toronto, "1st International W.A.V.E.

Video Exhibition," 1976; Women's Building, L.A., "Performance Transformations" and "What Is Feminist Art," 1977; University of Waterloo, Ont., "Postal Art," 1977; Annenberg School of Communication, University of Southern California, L.A., "Sensor," 1977; Contemporary Arts Museum, Houston, "American Narrative/Story Art, 1967-1977," 1977; San Diego State University, "Gray Matter," 1978; Los Angeles Institute of Contemporary Art, "Artwords/Bookworks" and "Public Domain/Private Shadows," 1978, "Social Works," 1979; Artemisia Gallery, Chicago, "Both Sides Now," 1979; Contemporary Art Center, New Orleans, "A Decade of Women's Performance Art," 1980; San Francisco Museum of Modern Art, "Public Disclosure: Secrets from the Street," 1980; Wright State University, Dayton, "Art of Conscience," 1980; Institute of Contemporary Arts, London, "Issue," 1980; Grey Art Gallery and Study Center, New York University, "Heresies Benefit Exhibition," 1981; Centro de Documentacio d'Art Actual, Barcelona, "Artists' Books," 1981; Beyond Baroque Literary/Arts Center, Venice, Ca., "Art and Society: Bookworks by Women," 1981; Weiner Secession, Vienna, "Extended Photography, 5th International Biennial," 1981; Anthology Film Archives, N.Y.C., "Video/Politics," 1981; State University of New York, Binghamton, "Nine Women Artists," 1982; Kitchen, N.Y.C., "Video by Women," 1982; Kassel, "Documenta 7," 1982.

Selected Bibliography:
Art of Conscience: The Last Decade, catalogue of exhibition organized by Wright State University, Dayton, 1980 (text by D.B. Kuspit, artists' statements); J. Weinstock, "Interview with Martha Rosler," October 17 (Summer 1981); 77-98; B. Barber and S. Guilbaut, "Performance as Social and Cultural Intervention: Interview with Martha Rosler," Parachute (Fall 1981): 28-32; M. Gever, "An Interview with Martha Rosler," Afterimage 9 (Oct. 1981): 10-17; Martha Rosler: 3 Works, Halifax: Press of the Nova Scotia College of Art and Design, 1981.

Susan Rothenberg

Born in Buffalo, New York, 1945
Lives in New York City

If an artist doesn't spend a long hard time making work in the studio, then the works themselves seem to lack the element of time. Creative time generates time as an experience that the viewer ought to have of the work. This is an essential part of what I want to communicate.

Selected One-Person Exhibitions:
112 Greene Street, N.Y.C, 1975; Willard Gallery, N.Y.C., 1976-77, 79, 81; University Art Museum, Berkeley, 1978; Walker Art Center, Minneapolis, 1978; Greenberg Gallery, St. Louis, 1978; Mayor Gallery, London, 1980; Galerie Rudolf Zwirner, Cologne, 1980; Akron Art Museum, 1981.

Selected Group Exhibitions:
Fine Arts Gallery, California State University, L.A., "New Work/New York," 1976; Holly Solomon Gallery, N.Y.C., "Ani-

mals," 1976; Sarah Lawrence College, Bronxville, N.Y., "Painting 76-77," 1977; P.S.1, Institute for Art and Urban Resources, Long Island City, "May Painting Show," 1977; Museum of Modern Art, N.Y.C., "New Acquisitions," "Extraordinary Women," and "American Drawn and Matched," 1977; New York State Museum, Albany, "New York: The State of Art," 1977; Joe & Emily Lowe Art Gallery, Syracuse University, "Critic's Choice," 1977; Cleveland Museum of Art, "Seven Artists: Contemporary Drawings," 1978; Protetch-McIntosh Gallery, Washington, D.C., "The Minimal Image," 1978; Vassar College Art Gallery, Poughkeepsie, "Hunt, Jenney, Lane, Rothenberg, Shapiro," 1978; Albright-Knox Art Gallery, Buffalo, "American Painting of the 1970's," 1978; Whitney Museum of American Art, N.Y.C., "New Image Painting" and "Biennial Exhibition," 1979; Renaissance Society at the University of Chicago, "Visionary Images," 1979; Grey Art Gallery and Study Center, New York University, "American Painting: The Eighties," 1979; Galerie Daniel Templon, Paris, "Tendances Actuelles de l'Art Americain," 1980; Padiglione d'Arte Contemporanea, Milan, "Horror Pleni: Pictures in New York Today," 1980; "39th Venice Biennale," 1980; Indianapolis Museum of Art, "Painting and Sculpture Today, 1980"; Young-Hoffman Gallery, Chicago, "Lane, Obuck, Rothenberg, Sultan, Torreano," 1981; University Art Galleries, University of California, Santa Barbara, "Contemporary Drawings: In Search of an Image," 1981; Goddard-Riverside Community Center, N.Y., "Menagerie," 1981; Institute of Contemporary Art, Virginia Museum of Fine Arts, Richmond, "A New Bestiary: Animal Imagery in Contemporary Art," 1981; Akron Art Museum, "The Image in American Painting & Sculpture 1950-1980," 1981; Kunsthalle Basel, "Robert Moskowitz, Susan Rothenberg, Julian Schnabel," 1981; Nassau County Museum of Fine Art, Roslyn, "Animals in American Art 1880-1980," 1981.

Selected Bibliography:
New Image Painting, catalogue of exhibition organized by the Whitney Museum of American Art, N.Y.C., 1978 (text by R. Marshall, artists' statements); M. Rosenthal, "From Primary Structures to Primary Imagery," Arts Magazine 53 (Oct. 1978): 106-7; American Painting: The Eighties, catalogue of exhibition curated by B. Rose at the Grey Art Gallery and Study Center, New York University, 1979; R. Smith, "The Abstract Image," Art in America 67 (Mar./Apr. 1979): 102ff. Susan Rothenberg, catalogue of exhibition organized by the Kunsthalle Basel, 1981 (text by P. Blum); I.M. Danoff, "Susan Rothenberg," Dialogue, The Ohio Arts Journal (Nov./Dec. 1981): 42-3.

David Salle

Born in Norman, Oklahoma, 1952
Lives in New York City

The obligatory is seen as the source of beauty.

Selected One-Person Exhibitions:
Project, Inc., Cambridge, 1975; Claire S. Copley Gallery, L.A., 1975; Corps de Garde, Groningen, 1976, 78; Artists Space, N.Y.C., 1976; Foundation de Appel, Amsterdam, 1977, 80; Kitchen, N.Y.C., 1977, 79; Real Art Ways, Hartford, 1978; Anna Leonowens Gallery, Nova Scotia College of Art and Design, Halifax, 1979; Gagosian/Nosei-Weber Gallery, N.Y.C., 1979; Annina Nosei Gallery, N.Y.C., 1980; Galerie Bischofberger, Zurich, 1980; Mary Boone Gallery, N.Y.C., 1981-82; Larry Gagosian Gallery, L.A., 1981; Galleria Lucio Amelio, Naples, 1981; Galleria Mario Diacono, Rome, 1982.

Selected Group Exhibitions:
California State College, L.A., "Conceptual Performance," 1974; Mt. San Antonio College, Walnut, Ca., "Word Works," 1974; Project, Inc., Cambridge, "Indian Summer," 1974; Long Beach Museum of Art, "Southland Video Anthology," 1975; Auction 393, N.Y.C., "New Talent Invitational," 1976; Serial Gallery, Amsterdam, "Locations," 1977; Hallwalls, Buffalo, 1977; Artists Space, N.Y.C., "New Art Auction and Exhibition," 1977, and "Return to Artists Space," 1981; Groninger Museum, Groningen, "Summerfestival," 1977-78; University Art Gallery, University of North Dakota, Grand Forks, "New Work—New York," 1977; Studio d'Arte Cannaviello, Milan, "Recognizable Images," 1979; Hal Bromm Gallery, N.Y.C., 1979; 80 Langton Street, S.F., "Masters of Love," 1979; Joseloff Gallery, Hartford Art School, University of Hartford, "Imitation of Life," 1979; Padiglione d'Arte Contemporanea, Milan, "Horror Pleni: Pictures in New York Today," 1980; Brooke Alexander, Inc., N.Y.C., "Illustration & Allegory," 1980; Allen Memorial Art Museum, Oberlin College, 1981; Museen der Stadt Köln, "Heute: Westkunst," 1981; Sperone Westwater Fischer, N.Y.C., 1981; California Institute of the Arts, Valencia, "Tenth Anniversary Exhibition," 1981; Albright-Knox Art Gallery, Buffalo, "Figures, Forms and Expressions," 1981; Hayden Gallery, Massachusetts Institute of Technology, Cambridge, "Figurative Aspects of Recent Art," 1981; Nigel Greenwood Ltd., London, 1981; Mattingly-Baker Gallery, Dallas, 1981; Konsthallen Göteborg, Sweden, "U.S. Art Now," 1981; Bard College, Annandale, N.Y., 1981; University Art Museum, University of California, Santa Barbara, "Figuration," 1982; Renaissance Society at the University of Chicago, "Art and Mass Media," 1982; Kassel, "Documenta 7," 1982.

Selected Bibliography:
D. Salle, "Images that Understand Us," Journal, Los Angeles Institute of Contemporary Art (June-July 1979): 41-4; J. Siegel, "David Salle: Interpretation of Image," Arts Magazine 51 (Apr. 1981): 94-5; P. Schjeldahl, "David Salle Interview," Journal, Los Angeles Institute of Contemporary Art (Sept.-Oct. 1981): 15-21; C. Owens, "Back to the Studio," Art in America 70 (Jan. 1982): 102-4; C. Ratcliff, "David Salle," Interview 12 (Feb. 1982): 64-6.

Julian Schnabel

Born in New York City, 1951
Lives in New York City

"...when we speak the word 'life,' it must be understood we are not referring to life as we know it from its surface of fact, but to that fragile, fluctuating center which forms never reach. And if there is still one hellish, truly accursed thing in our time, it is our artistic dallying with forms, instead of being like victims burnt at the stake, signalling through the flames."
(from the preface to The Theater and Its Double by Antonin Artaud)

I would like to discuss the state, if any can exist, that approximates the meanings of my paintings. Rather than discussing each work, I would like to address the work. All of the things that I have made, the varied materials and subjects, the various objects that they have become, all run together in my mind as one body with so many faces as to be faceless. Their accumulative meaning as physical facts act as signifiers for a battle.

The battle of existence. The conscious recognition of the simultaneous state of a moment filled with longing, anxiety, curiosity, fear, death, religiosity, the remembrance of every pertinent impetus nameable and unnameable. Friends living and dead, friends I used to know. The disillusionment with their loss. The remembrance of the circumstances surrounding our split. The recollection of the way they stood and answered when you noticed how they changed. The way your stomach felt, bloated, anticipating cancer. Nerves perhaps. The recognition of devotion. The physical manifestation of character, stability and good will—optimism.

The opacity that one meets from his or her inanimate objects as they are questioned to name themselves or asked what to do next. The uplifting verticality, the ascending power of love felt. The horizontal plane leveling all things of different kind, all having equal weight. The fear of the loss of love and of the horror of your worst fears. The feelings of this moment are beckoned by those physical facts, that were begot by these recognitions.

Selected One-Person Exhibitions:
Contemporary Arts Museum, Houston, 1976; Galleria Ruggiero, Milan, 1977; Galerie Dezember, Düsseldorf, 1978; Mary Boone Gallery, N.Y.C., 1979, 81; Daniel Weinberg Gallery, S.F., 1979; Galerie Bischofberger, Zurich, 1980; Young-Hoffman Gallery, Chicago, 1980; Stedelijk Museum, Amsterdam, 1982.

Selected Group Exhibitions:
University of St. Thomas, Houston, "Hidden Houston," 1971; Louisiana Gallery, Houston, 1972; Whitney Museum of American Art, N.Y.C., "W.I.S.P. Exhibition," 1974, and "1981 Biennial Exhibition"; Holly Solomon Gallery, N.Y.C., "Surrogate/Self Portraits," 1977; Renaissance Society at the University of Chicago, "Visionary Images," 1979; Hallwalls, Buffalo, "Four Artists," 1979; Daniel Templon, Paris, 1980; Mary Boone Gallery, N.Y.C., "Drawings," 1981, and "Group Show," 1982; Yarrow/Salzman Gallery, Toronto, "New Work/New York," 1980; "39th Venice Biennale," 1980; Institute of Contemporary Art, Virginia Museum of Fine Arts, "On Paper," 1980; Leo Castelli Gallery, N.Y.C., "Benefit for the Foundation of Performance Arts, Inc.," 1980; New

Gallery of Contemporary Art, Cleveland, "New Talent/New York," 1980; Mattingly Baker Gallery, Dallas, "Drawings," 1980; Annina Nosei Gallery, N.Y.C., 1980; Royal Academy of Arts, London, "A New Spirit in Painting," 1981; Galerie Bischofberger, Zurich, "Group Show," 1981; Museen der Stadt Köln, "Heute: Westkunst," 1981; Anthony D'Offay Gallery, London, 1981; Kunsthalle Basel, "Robert Moskowitz, Susan Rothenberg, Julian Schnabel," 1981; Akron Art Museum, "The Image in American Painting & Sculpture, 1950-1980," 1981; Hayden Gallery, Massachusetts Institute of Technology, Cambridge, "Figurative Aspects of Recent Art," 1981; Konsthallen Göteborg, Sweden, "U.S. Art Now," 1981; Institute of Contemporary Art, Boston, "Issues: New Allegory," 1982; Ronald Feldman Gallery, N.Y.C., "Sweet Art," 1982.

Selected Bibliography:
C. Ratcliff, "Art to Art: Julian Schnabel," Interview Magazine (Oct. 1980): 55-7; K. Kertess, "Figuring It Out," Artforum 18 (Nov. 1980): 34-5; R. Pincus-Witten, "Entries: Sheer Grunge," Arts Magazine 55 (May 1981): 94, 96-7; B. Cavaliere, "Julian Schnabel," Arts Magazine 55 (June 1980): 34-5; R. Ricard, "A Note About Julian Schnabel," Artforum 19 (Summer 1981): 74-80; R. Pincus-Witten, "Julian Schnabel: Blind Faith," Arts Magazine 56 (Feb. 1982): 152-5.

Joel Shapiro

Born in New York City, 1941
Lives in New York City

Arrested motion and a dream/lavender clouds the form.

Chopped appendages off, disfiguring.

Small additive wood figure, elated. Stuck on additional appendages—leg, arm, head. These are made of wax, modelled, loaded. Juxtaposition disrupts form.

Selected One-Person Exhibitions:
Paula Cooper Gallery, N.Y.C., 1970, 72, 74-77, 79-80, 82; Clocktower, Institute for Art and Urban Resources, N.Y.C., 1973; Galleria Salvatore Ala, Milan, 1974; Garage, London, 1975; Walter Kelly Gallery, Chicago, 1975; Museum of Contemporary Art, Chicago, 1976; Max Protetch Gallery, Washington, D.C., 1977; Galerie Nancy Gillespie-Elisabeth de Laage, Paris, 1977, 79; Galerie Aronowitsch, Stockholm, 1977, 80; Galerie M., Bochum, 1978; Akron Art Institute, 1979; Ohio State University, Columbus, 1979; Whitechapel Art Gallery, London, 1980; Museum Haus Lange, Krefeld, 1980; Brooke Alexander, Inc., N.Y.C., 1980; Moderna Museet, Stockholm, 1980; Bell Gallery, List Art Center, Brown University, Providence, 1980; Ackland Art Museum, University of North Carolina, Chapel Hill, 1981; Georgia State University, Atlanta, 1981; John Stoller Gallery, Minneapolis, 1981; Daniel Weinberg Gallery, S.F., 1981; Contemporary Arts Center, Cincinnati, 1981; Israel Museum, Jerusalem, 1981; Young-Hoffman Gallery, Chicago, 1981; Susanne Hilberry Gallery, Birmingham, Mi., 1982.

Selected Group Exhibitions:
Whitney Museum of American Art,

N.Y.C., "Anti-Illusion: Procedures/Materials," 1969, "1970 Sculpture Annual," "American Drawings 1963-73," 1973; "Biennial Exhibition," 1977, 79, 81, "Small Objects" (Downtown), 1977, "American Art since 1950" and "Architectural Analogues" (Downtown), 1980, "New Acquisitions," 1981; Museum of Modern Art, N.Y.C., "Paperworks," 1970; Art Institute of Chicago Society for Contemporary Art, "Annual Exhibition," 1971, 75; Albright-Knox Art Gallery, Buffalo, "Kid Stuff," 1971, and "Figures, Forms and Expressions," 1981; Aldrich Museum of Contemporary Art, Ridgefield, Ct., "Painting on Paper," 1972, "The Minimal Tradition," 1979, "New Dimensions in Drawing," 1981; Art Institute of Chicago, "71st American Exhibition," 1975; Fine Arts Building, N.Y.C., "Scale," "Roelof Louw, Marvin Torfield, Joel Shapiro: New Sculpture, Plans and Projects" and "Sculptors' Drawings," 1976; University Gallery, Fine Arts Center, University of Massachusetts, Amherst, "Critical Perspectives in American Art," 1976; Renaissance Society at the University of Chicago, "Ideas on Paper 1970-1976," 1976, and "Ideas in Sculpture 1965-1977," 1977; "Venice Biennale," 1976, 80; Akademie der Künste, Berlin, "New York-Downtown Manhattan: Soho," 1976; Grey Art Gallery and Study Center, New York University, "Project Rebuild," 1976, and "Perceiving Modern Sculpture: Selections for the Sighted and Non-Sighted," 1980; Institute of Contemporary Art of the University of Pennsylvania, Philadelphia, "Improbable Furniture," 1977, and "Dwellings," 1978; Visual Arts Museum, N.Y.C., "A Question of Scale," 1977, and "Sculptural Density," 1981; Kassel, "Documenta," 1977, 82; Museum of Contemporary Art, Chicago, "A View of a Decade," 1977; Walker Art Center, Minneapolis, "Scale and Environment: 10 Sculptors," 1977; New Museum, N.Y.C., "Early Work by Five Contemporary Artists," 1977; P.S.1, Institute for Art and Urban Resources, Long Island City, "Indoor/Outdoor," 1978, and "Figuratively Sculpting," 1981; Stedelijk Museum, Amsterdam, "Made by Sculptors," 1978; University Art Galleries, University of California, Santa Barbara, "Contemporary Sculpture: Researches in Scale," 1979; Städtische Galerie im Lenbachhaus, Munich, "Tendencies in American Drawings of the Late Seventies," 1979; Kulturhistorisches Museum, Bielefeld, "Zeitgenössische Plastik," 1980; Hayward Gallery, London, "Pier & Ocean," 1980; Westfälisches Landesmuseum für Kunst und Kulturgeschichte, Münster, "Reliefs, Formprobleme zwischen Malerei und Skulptur im 20 Jahrhunderts," 1980; Los Angeles Institute of Contemporary Art, "Architectural Sculpture," 1980; Brooklyn Museum, "American Drawing in Black and White," 1980; Musée Nationale d'Art Moderne, Centre Georges Pompidou, Paris, "Nature du Dessin," 1980; Albright-Knox Art Gallery, Buffalo, "Constructivism and the Geometric Tradition: Selections from the McCrory Corporation Collection," 1981; Sewall Art Gallery, Rice University, Houston, "Variants: Drawings by Contemporary Sculptors," 1981.

Selected Bibliography:
M. Field, "On Joel Shapiro's Sculptures and Drawings," Artforum 16 (Summer 1978): 31-7; J. Coplans, "Joel Shapiro: An Interview," Dialogue, The Ohio Arts Journal (Jan./Feb. 1979): 7-9; Joel Shapiro: Sculpture and Drawing, catalogue of exhibition organized by the Whitechapel Art Gallery, London, 1980 (text by R. Smith); Joel Shapiro, catalogue of exhibition organized by the Bell Gallery, List Art Center, Brown University, Providence, 1980 (text by W.H. Jordy).

James Turrell

Born in Los Angeles, California, 1943
Lives in Flagstaff, Arizona

Rayna is a sensing space. It receives light only from the space immediately outside itself, the room in which you stand. It is an expression of that space. The walls of the space outside are directly lit. Light reflected off these surfaces enters the sensing space. The space is not empty. The quality of the light inhabiting this space is my interest. The existence of the piece is changed by you. It is about your seeing, though an expression of mine.

Selected One-Person Exhibitions:
Pasadena Art Museum, 1967; Main and Hill Studio, Santa Monica, 1968-70; Stedelijk Museum, Amsterdam, 1976; Arco Center for Visual Arts, Los Angeles, 1976; Herron School of Art Gallery, Indianapolis, 1980; Museum of Art, University of Arizona, Tucson, 1980; Whitney Museum of American Art, N.Y.C., 1980; Leo Castelli Gallery, N.Y.C., 1980; Portland Center for the Visual Arts, Or., 1981; Center on Contemporary Art, Seattle, 1982.

Selected Bibliography:
Avaar, A Light Installation, catalogue of exhibition organized by the Herron School of Art, Indianapolis, 1980 (text by C. Adney); J. Butterfield, "A Hole in Reality," Images and Issues 1 (Fall 1980): 53-7; James Turrell: Light and Space, catalogue of exhibition organized by the Whitney Museum of American Art, N.Y.C., 1981 (text by M. Wortz, commentaries by J. Turrell); K. Larson, "Dividing the Light from the Darkness," Artforum 19 (Jan. 1981): 30-3; N. Marmer, "James Turrell: The Art of Deception," Art in America 69 (May 1981): 90-9; James Turrell, catalogue of exhibition organized by the Center on Contemporary Art, Seattle, 1982.

Richard Tuttle

Born in Rahway, New Jersey, 1941
Lives in New York City

Ice Floats

Today, although the temperature was in the 60's, there was still ice on the lake I saw. "But ice is so heavy," I thought, "Why does it float? Does it have little pieces of air trapped in it by freezing? But water is heavy. Perhaps even heavier than ice." Then, I was glad ice floats.

Selected One-Person Exhibitions:
Betty Parsons Gallery, N.Y.C., 1965, 67, 68, 70, 72, 74-75, 78; Galerie Schmela, Düsseldorf, 1968, 78; Albright-Knox Art Gallery, Buffalo, 1970; Galerie Zwirner, Cologne, 1970, 72; Dallas Museum of

Fine Arts, 1971; Museum of Modern Art, N.Y.C., 1972; Galerie Yvon Lambert, Paris, 1972, 74, 76, 78, 81; Kunstraum, Munich, 1973, 77; Daniel Weinberg Gallery, S.F., 1973, 78; Galerie Annemarie Verna, Zurich, 1973, 79, 81, 82; Clocktower, Institute for Art and Urban Resources, N.Y.C., 1973; Nigel Greenwood Ltd., London, 1974, 77, 82; Whitney Museum of American Art, N.Y.C., 1975; Wadsworth Atheneum, Hartford, 1975; Otis Art Institute of Parsons School of Design, L.A., 1976; University of Western Ontario, London, 1976; Ohio State University Gallery, Columbus, 1977; Galleria Ugo Ferranti, Rome, 1977, 79, 81-82; Kunsthalle Basel, 1977; Young-Hoffman Gallery, Chicago, 1978; Bell Gallery, List Art Center, Brown University, Providence, 1978; Museum van Hedendaagse Kunst, Ghent, 1978; Stedelijk Museum, Amsterdam, 1979; University Art Galleries, University of California, Santa Barbara, 1979; Centre d'Arts Plastiques Contemporains, Bordeaux, 1979; Centre d'Art Contemporain, Ghent, 1980; Museum Haus Lange, Krefeld, 1980; Baxter Art Gallery, California Institute of Technology, Pasadena, 1980; University of Georgia, Atlanta, 1980.

Selected Group Exhibitions:
Des Moines Art Center, "Painting Out from the Wall," 1968; Detroit Institute of Arts, "Other Ideas," 1968; Finch College Museum of Art, N.Y.C., "Betty Parsons' Private Collection," 1968; Kunsthalle Bern, "When Attitudes Become Form," 1969; Washington University Gallery of Art, St. Louis, "Here and Now," 1969; Corcoran Gallery of Art, Washington, D.C., "31st Biennial Exhibition," 1969; American Federation of Arts Gallery, N.Y.C., "American Painting: the 1960's," 1969, and "Recent Drawings," 1975; New Jersey State Museum, Trenton, "Soft Art," 1969; Trinity College, Hartford, "New Materials," 1970; Jewish Museum, N.Y.C., "Using Walls," 1970; Bennington College, "Paintings without Supports," 1971; Kassel, "Documenta," 1972, 77, 82; Munson-Williams-Proctor Institute, Utica, "Recent Paintings and Sculptures," 1972; Fogg Art Museum, Harvard University, Cambridge, "New American Graphic Art," 1973; Städtische Galerie im Lenbachhaus, Munich, "Bilder-Objekte-Filme-Konzepte," 1973; Newark Museum, "Works on Paper," 1973; Yale University Art Gallery, New Haven, "Options and Alternatives: Some Directions in Recent Art," 1973, and "Mel Bochner, Barry Le Va, Dorothea Rockburne, Richard Tuttle," 1975; Whitney Museum of American Art, N.Y.C., "American Drawings, 1963-1973," 1973, and "Small Objects" (Downtown), 1977; Centro Communitario di Brera, Milan, "Arte Come Arte," 1973; Incontri Internazionali d'Arte, Rome, "Contemporanea," 1974; Museum of Modern Art, N.Y.C., "Drawings on Paper" and "Cut, Folded, Pasted & Torn," 1974, "Drawing Now," 1976; Art Museum, Princeton University, "Line as Language, Six Artists Draw," 1974; Baltimore Museum of Art, "14 Artists," 1975; Art Institute of Chicago, Society for Contemporary Art, "The Small Scale in Contemporary Art," 1975; Schloss Morsbroich, Städtisches Museum, Leverkusen, "Zeichnungen 3," 1975; Fine Arts Building, N.Y.C., "Scale,"

1975; School of Visual Art, N.Y.C., "Line," 1976; P.S.1, Institute for Art and Urban Resources, N.Y.C., "Rooms," 1976; University of Massachusetts, Amherst, "Critical Perspectives in American Art," 1976; Philadelphia College of Art, "Artists' Notebooks," 1976; School of Art and Architecture, Yale University, New Haven, "Long, LeWitt, Tuttle," 1977; Museum of Contemporary Art, Chicago, "A View of a Decade," 1977; Galerie Nancy Gillespie-Elisabeth de Laage, Paris, "Avant-Garde Russe, Avant-Garde Minimaliste," 1978; Drew University, Madison, N.J., "The Reality of Art," 1979; Stedelijk Museum, Amsterdam, "Door Beeldhouwers gemaakt," 1978, and "'60 to '80," 1982; Palazzo Reale, Milan, "Colori e Ambiente," 1979; Musee National d'Art Moderne, Centre Georges Pompidou, Paris, "Murs," 1981.

Selected Bibliography:
Richard Tuttle, catalogue of exhibition organized by the Whitney Museum of American Art, N.Y.C., 1975 (text by M. Tucker); *List of Drawing Material by Richard Tuttle*, Zurich, 1979 (text by J. Johnen, J. Hoët, R. Jorris, J. Glaesemer, and R. Tuttle); *Richard Tuttle*, catalogue of exhibition organized by the Museum Haus Lange, Krefeld, 1980 (text by M. Stockebrand).

Christopher Williams

Born in Los Angeles, California, 1956
Lives in Los Angeles, California

Source:
The Photographic Archive, John F. Kennedy Library, Columbia Point on Dorchester Bay, Boston, Massachusetts 02125

Conditions for Selection:
There are two conditions: the photograph or photographs must be dated May 10, 1963, and the subject, John F. Kennedy, must have his back turned toward the camera. All photographs on file fulfilling these requirements are used.

Technical Treatment:
The photographs are subjected to the following operations: rephotography (4x5" copy negative), enlargement (from 8x10" to 11x14" by use of the copy negative), and cropping (1/16" is removed from all sides of the rephotographed, enlarged image).

Presentation:
74th American Exhibition, June 12–August 1, 1982, Morton Wing/A. Montgomery Ward Gallery, The Art Institute of Chicago, Michigan Avenue at Adams Street, Chicago, Illinois 60603 Christopher Williams

Selected One-Person Exhibitions:
California Institute of the Arts, Valencia, 1979-81; Jancar/Kuhlenschmidt Gallery, L.A., 1982.

Selected Group Exhibitions:
California Institute of the Arts, Valencia, "Approximately One-Half Hour of Dance Activity (An Unrehearsed Situation)," 1978, and "Public Speaking Work," 1980; Vancouver School of Art, "Group Exhibition of Some CalArts Works and Other People Who Have Passed Through," 1979; University of Hartford, 1979; Addison Gallery of American Art, Phillips

Academy, Andover, 1979; Otis Art Institute of Parsons School of Design, L.A., "5 Artists from CalArts," 1980; Wiener Secession, Vienna, "Extended Photography, 5th International Biennial," 1981.

Selected Bibliography:
Extended Photography, 5th International Biennial, catalogue of exhibition organized by the Wiener Secession, Vienna, 1982 (text by A. Auer and P. Weibel).

Ray Yoshida

Born in Kapaa, Kauai, Hawaii, 1930
Lives in Chicago, Illinois

Acknowledging my own shortcomings, I try to absorb all the contradictions, tragedies, aberrations, all the laughter, smiles, sarcasms and futilities—and go through the pains and pleasures of painting.

Selected One-Person Exhibitions:
Phyllis Kind Gallery, Chicago, 1975, 77, 81.

Selected Group Exhibitions:
Institute of Contemporary Art of the University of Pennsylvania, Philadelphia, "Spirit of the Comics," 1969; Museum of Contemporary Art, Chicago, "Don Baum Sez 'Chicago Needs Famous Artists,'" 1969, and "Chicago Imagist Art," 1972; San Francisco Art Institute, "Serplus Slop from the Windy City," 1970; National Gallery of Canada, Ottawa, "What They're Up To in Chicago," 1972; "XII Biennal de São Paulo: Made in Chicago," 1974; Art Institute of Chicago, "Exhibition by Artists of Chicago and Vicinity," 1974, 78, 80, "100 Artists, 100 Years," 1979; School of the Art Institute of Chicago, "Visions/Painting and Sculpture: Distinguished Alumni, 1945 to the Present," 1976; E.B. Crocker Art Gallery, Sacramento, "The Chicago Connection," 1977; University of Northern Iowa Gallery of Art, Cedar Falls, "Contemporary Chicago Painters," 1978; Florida State University, Tallahassee, "Eleven Chicago Painters," 1978; Koffler Foundation, National Collection of Fine Arts, Washington, D.C., "Chicago Currents," 1979; Ackland Art Museum, University of North Carolina, Chapel Hill, "Some Recent Art from Chicago," 1980; Sunderland Arts Centre, England, "Who Chicago?," 1980.

Selected Bibliography:
Contemporary Chicago Painters, catalogue of exhibition organized by the University of Northern Iowa Gallery of Art, Cedar Falls, 1978 (intro. by S.S. Shaman); *Eleven Chicago Painters,* catalogue of exhibition organized by Florida State University, Tallahassee, 1978; *Some Recent Art from Chicago,* catalogue of exhibition organized by the Ackland Art Museum, University of North Carolina, Chapel Hill, 1980 (introduction by K. Lee Keefe); *Who Chicago?,* catalogue of exhibition organized by the Sunderland Arts Centre, England, 1980 (text by V. Musgrove, D. Adrian, R. Bowman, and R. Brown).